IMAGES
of America
LAS CRUCES

For John Richards

Jon Hunner, Brian Kord,
Cassandra Lachica, and Renee Spence

Copyright © 2003 by Jon Hunner, Brian Kord, Cassandra Lachica, and Renee Spence.
ISBN 978-0-7385-2097-1

Published by Arcadia Publishing
Charleston, South Carolina

Printed in the United States of America

Library of Congress Catalog Card Number: 2003106589

For all general information contact Arcadia Publishing at:
Telephone 843-853-2070
Fax 843-853-0044
E-mail sales@arcadiapublishing.com
For customer service and orders:
Toll-Free 1-888-313-2665

Visit us on the Internet at www.arcadiapublishing.com

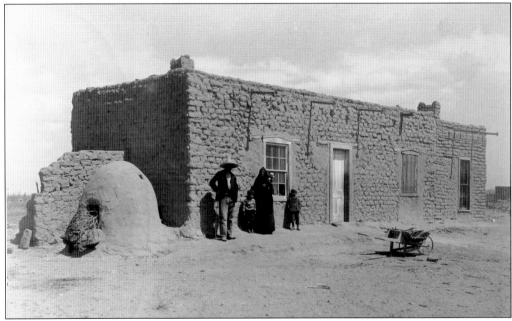

A typical adobe home in the late 19th century illustrates some of the ancient building techniques of the desert Southwest. Sun-dried mud bricks, flat roofs, extended *canales* (roof drains) and an *horno* (beehive) outdoor cooking oven on the left all were traditional elements handed down through the generations. Note the added room on the right of the house, possibly to accommodate this young family's growth. (Courtesy of New Mexico State University Library Archives and Special Collections Department [NMSULASP].)

Cover: Headed south on Main Street towards Loretto Academy on Christmas Day, 1896, sombrero-clad travelers in a wagon demonstrate the incredible mix of cultures that has enriched Las Cruces city since its birth. (Courtesy of NMSULASP.)

CONTENTS

Acknowledgments 6

Introduction 7

1. Las Cruces in the Gilded Age 9

2. Early 20th Century in the City of Crosses 43

3. The Depression, World War II, and a Return to Peace and Prosperity 79

4. Urban Renewal Changes the Heart of Las Cruces 113

ACKNOWLEDGMENTS

The historical photos in *Las Cruces* came from either the Rio Grande Historical Collection at New Mexico State University (NMSULASP) or from the Institute of Historical Survey (IHSF), both wonderful archives in Las Cruces. Many thanks go to Steve Hussman and Dennis Dailey at the Rio Grande Historical Collection and to Evan Davies, Anne Morgan and Ann Moore at IHS. Our thanks also go to Patsy Montoya and Nancy Shockley in the History Department at NMSU.

 This book was created by students and faculty in the Public History Program at New Mexico State University in Las Cruces. It is the second in a series of historical photo books that we have published with Arcadia Publishing (the first was on Santa Fe). Many people have worked on it over the last year and a half. Lucinda Silva and Pedro Dominguez conducted the initial research. In the fall of 2002, Katie Brack, Brian Kord, Cassandra Lachica, John Richards, Renee Spence, Nancy Shockley, and M. Grant Bell continued to research, assemble photos, and write captions in the Historical Editing course that I taught. Brian, Cassandra, Renee, and I finished the book in the spring of 2003. Sadly, John Richards died as we were doing the final assembly of the book. We dedicate *Las Cruces* to his memory and will put all of the proceeds that we earn from this book in the John Richards Memorial Fund to support the graduate students in the Public History Program. Thank you for supporting us at NMSU with the purchase of this book. Please visit our website at http://web.nmsu.edu/~publihist for more information about our program.

<div style="text-align: right;">
Dr. Jon Hunner Director

Public History Program

New Mexico State University
</div>

Introduction

For hundreds of years before the earliest of these photographs was taken, this river valley in the Chihuahuan Desert served as a great intersection of peoples and cultures. In 1535, Alvar Nuñez Cabeza de Vaca traveled through the region and his presence heralded the beginning of a new world for Spanish explorers and the end of an ancient one for the native peoples.

Sixty-three years later, Don Juan de Oñate brought European settlers on what became known as *El Camino Real* (the Royal Road) that extended from Mexico City to Santa Fe. The long journey between the two destinations was very arduous, but the stretch starting near Las Cruces and running 90 miles north, called the *Jornada Del Muerto* (Journey of the Dead Man), was by far the most arid and possibly the most deadly. Perhaps knowing what lay ahead helped early travelers to relish the comfortable shade of the *Mesilla* (Little Table) Valley and it became a coveted oasis for many.

While the Mesilla Valley offered protection from thirst and heat, a different danger awaited those passing through the region. The Apache people had become infuriated with the increasing numbers of settlers passing through their land and at times, attacked the caravans. One story tells of a massacre that took place in the mid-19th century when travelers in a caravan met their deaths at Apache hands. The lone survivor erected crosses to honor those killed in the sand dunes along the trail. In 1846, Susan Shelby Magoffin, a traveler along the trail, noted the crosses in her diary and the name *El Pueblo del Jardin de Las Cruces* (the City of the Garden of the Crosses) may have evolved from her observation.

Despite occasional Apache raids, the area remained a welcome rest stop between major cities in Hispanic America until 1848, when the Mexican-American War ended with the Treaty of Guadalupe-Hidalgo. The haven then grew into a thriving crossroads, ushering Mexican and American settlers towards the many budding Southwestern communities. With the Rio Grande as the international border, Mesilla became a major settlement for many Mexicans who decided to make the thoroughfare a permanent home.

As the once sleepy valley bustled with activity, a local leader from the neighboring U.S. community of Doña Ana, Don Pablo Melendres, petitioned the United States government to establish a new town to the south of his overcrowded village. In 1849, the U.S. Army sent Lt. Delos Bennett Sackett

to survey the chosen site for the newly arriving settlers. After choosing locations for the church and plaza, Sackett measured 84 blocks of land with a rawhide rope. He then had the 120 individuals already living there draw numbered slips from an upturned hat to allot plots of land. The rest stop and burial place along *El Camino Real* had given birth to the town of Las Cruces.

In 1853, the U.S. ambassador to Mexico, John Gadsden, paid the hefty sum of $10 million to Mexican President Santa Ana to purchase a large strip of land that extended west of the Rio Grande and thus, brought Mesilla into the United States. By that time, Mesilla had grown into a large community that dwarfed Las Cruces and was the largest town between San Antonio and San Diego.

During the Civil War, the Confederate Army captured the Mesilla Valley, but then retreated back to Texas after their defeat in northern New Mexico. Nonetheless, the California Column of U.S. Army volunteers arrived in the valley in July 1862 to protect it from the rebels. This influx of young, skilled bachelors provided ample resources for the rapid development of the valley and an accompanying population boom.

Las Cruces remained a quiet suburb of Mesilla until 1881, when Don Jacinto Armijo planted the seed that would become the second largest city in New Mexico. Railroads were being built across the country, looking for sturdy villages in which to build their hubs. Mesilla, already a major crossroads, seemed an obvious candidate. However, Mesilla landowners balked at the idea of giving the right of way to a large railroad corporation. Don Jacinto Armijo eagerly waved the transportation magnates back across the river to Las Cruces, who agreed to build a depot on Armijo's land west of the townsite that Sackett had mapped out. Less than a year later, Mesilla had lost the county seat to Las Cruces and became a quiet suburb to the City of Crosses.

At this point, our book begins. Where 84 blocks of land were once drawn out of a hat and given to whoever would have them, a thriving metropolis now stands. *Las Cruces* begins with some of the earliest photographs of the town, traces its development, and closes with the radical transformation of the downtown area as a result of the urban renewal efforts of the 1970s.

<div style="text-align: right;">
M. Grant Bell and Dr. Jon Hunner
NMSU
</div>

One
LAS CRUCES IN THE GILDED AGE

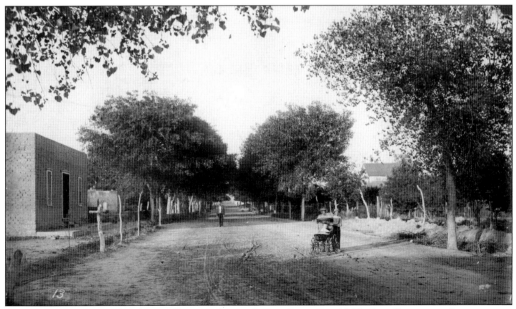
A young Las Cruces family strolls west down Griggs Street in 1892. Las Cruces at the time was an urban oasis of sorts in a largely unsettled and wide-open west. (Courtesy of NMSULASP.)

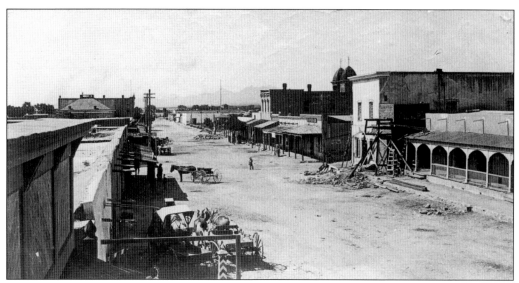
Looking north on Main Street, St. Genevieve's steeples are visible behind the new construction on the right. These spires later met an unfortunate end in the 1960s. (Courtesy of NMSULASP.)

A horse-drawn wagon sits in front of an old adobe building. This probably was a trading post where passersby or regulars could buy goods to tide them over until their next trip into Las Cruces. (Courtesy of NMSULASP.)

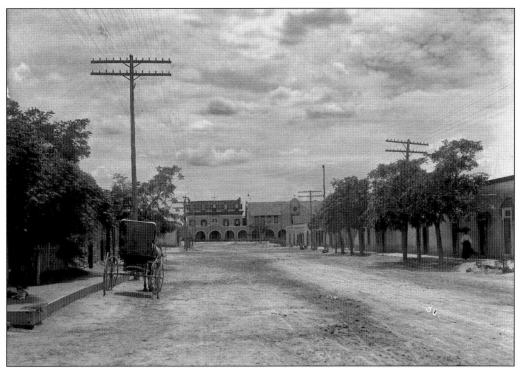

At the south end of Main Street, this horse and buggy plods toward Loretto Academy. The Sisters of Loretto founded the Academy in 1870. Loretto Academy was the first school in southern New Mexico and west Texas. (Courtesy of NMSULASP.)

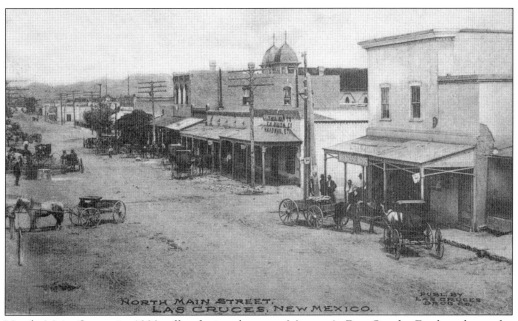

North Main Street in 1922 offered city shoppers Manesse's Dry Goods. Further down the street is a large sign directing "This way to Bascom-French Hardware." Note the steeples of St. Genevieve's Church in the background. (Courtesy of NMSULASP.)

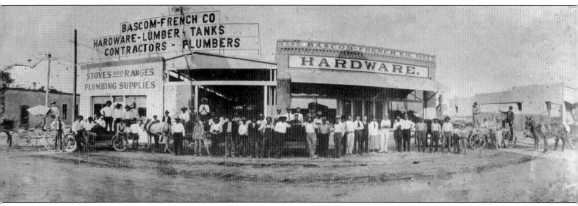

Masses of people gather in front of the Bascom-French Company Hardware Store. The large signs make sure that all who pass see the store and its goods. The sign to the right stated that the company was established in 1885. (Courtesy of NMSULASP.)

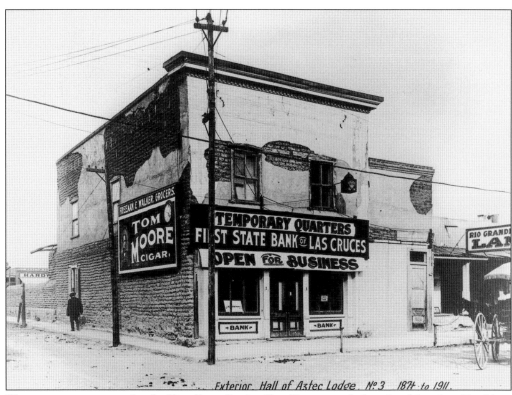

The temporary quarters for the First State Bank of Las Cruces resided in this dilapidated building next to the Rio Grande Land Company, a local realty office. In the background on the left, note the Bascom-French Hardware store sign. (Courtesy of NMSULASP.)

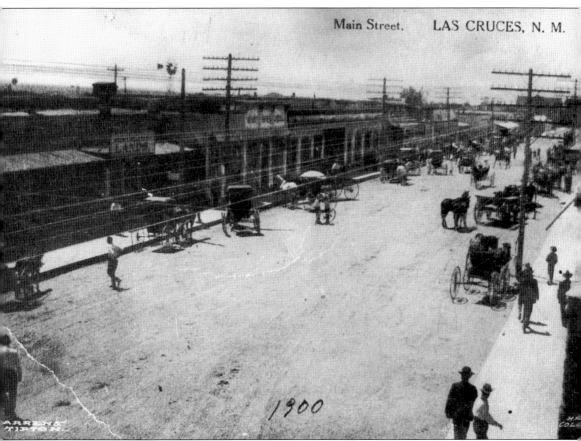

Main Street in 1900 throngs with people and carriages on both sides of the street. This turn-of-the-century photograph shows the great growth of the small railroad town. The multitude of telephone and telegraph poles demonstrate the progress the town has made by the beginning of the 20th century. (Courtesy of NMSULASP)

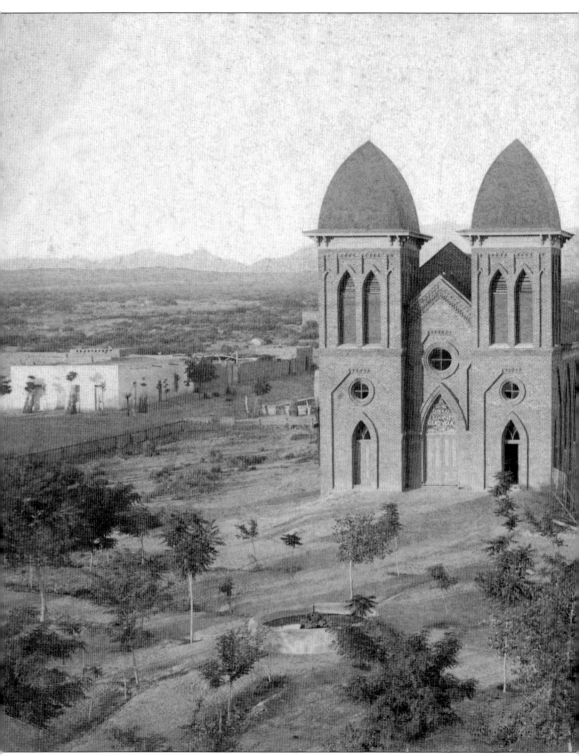

St. Genevieve's Catholic Church towers over the rest of Las Cruces, as it did throughout its seven-decade history. Built in the early 1890s to replace an older adobe church built in 1859,

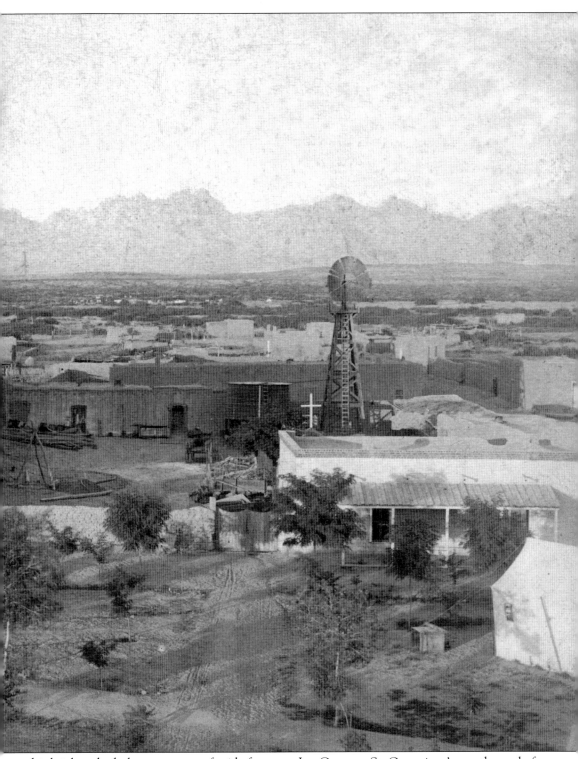
this brick cathedral was a source of pride for many Las Crucens. St. Genevieve's was the soul of downtown, yet it was tragically demolished in the 1960s. (Courtesy of NMSULASP.)

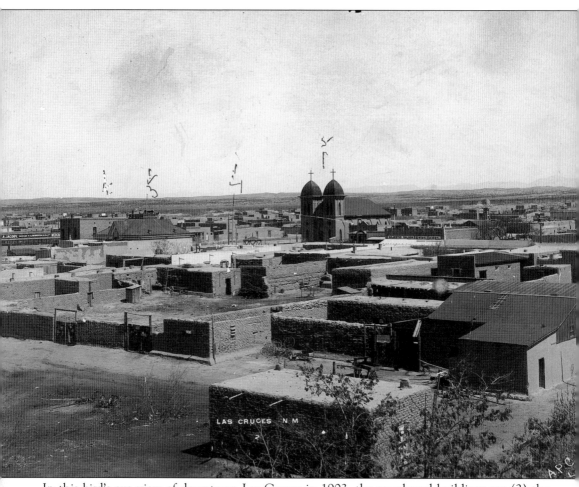

In this bird's-eye view of downtown Las Cruces in 1903, the numbered buildings are (2) the Reymond Building, (3) the Adolph Jacoby residence, and (5) St. Genevieve's Catholic Church. Also included in the photograph is the Adolph Jacoby Store to the left in the background. (Courtesy of NMSULASP.)

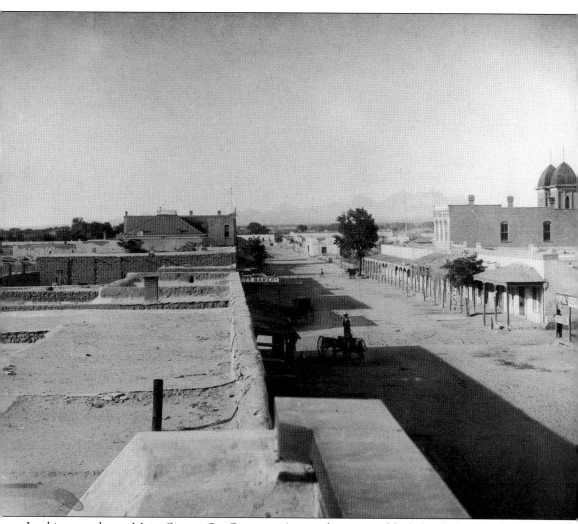

Looking north on Main Street, St. Genevieve's steeples are visible behind the Hotel Don Bernardo on the right side of the street. The unmistakable front of this popular hotel makes its unique mark on the street. (See also pages 40 and 41.) (Courtesy of NMSULASP.)

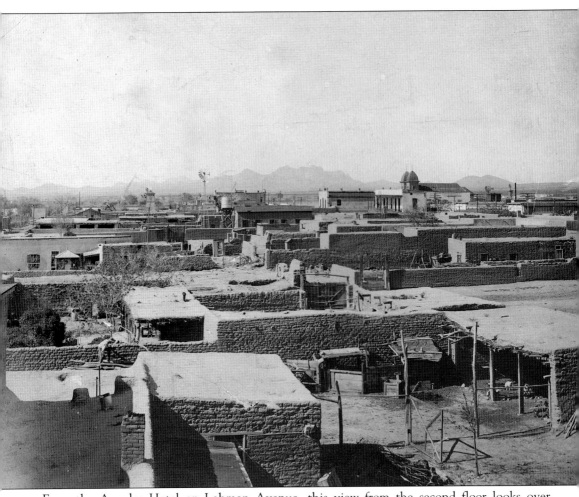

From the Amador Hotel on Lohman Avenue, this view from the second floor looks over downtown. A typical Las Cruces courtyard and corral are in the immediate foreground. Note St. Genevieve's and the Doña Ana Mountains in the background. With the scarcity of wood, dried mud bricks called adobes were the building material of choice. Because of scant rainfall, flat roofs were adequate for proper drainage in the southwestern region. (Courtesy of NMSULASP.)

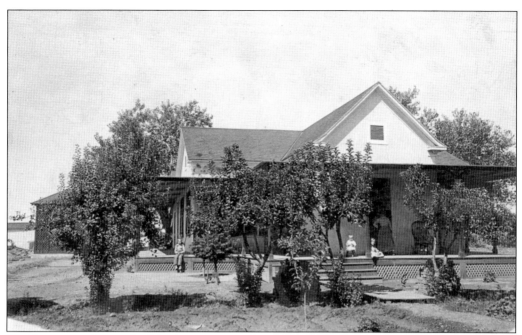

Children sit on the porch of this home in a residential area of Las Cruces. After the railroad arrived in 1881, homes like this were built west of downtown, and the Alameda neighborhood between the train depot and downtown became the fashionable place to live. (Courtesy of NMSULASP.)

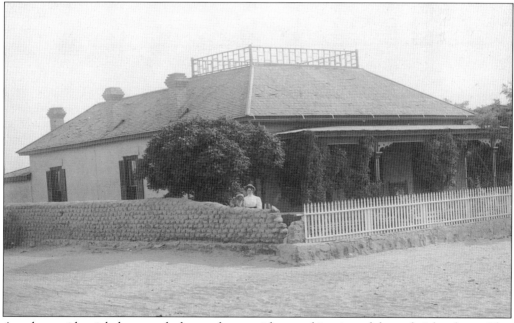

Another residential photograph shows a home with a combination adobe and picket fence. This photograph also illustrates how a prosperous family imported milled lumber for their fences and pitched roof. (Courtesy of NMSULASP.)

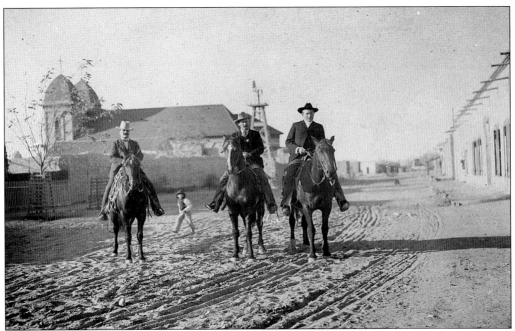

From left to right are Doña Ana County lawmen Felipe Lucero, Bob Burch, and Morgan Llewellyn on Church Street behind St. Genevieve's. (Courtesy of NMSULASP.)

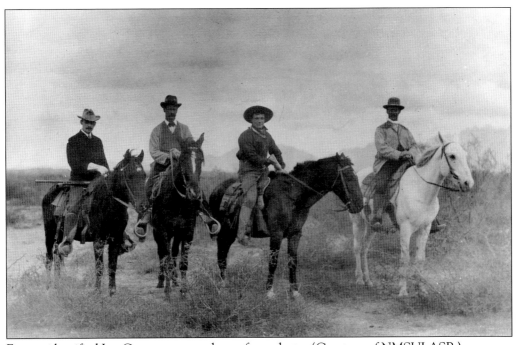

Four unidentified Las Crucens stop and pose for a photo. (Courtesy of NMSULASP.)

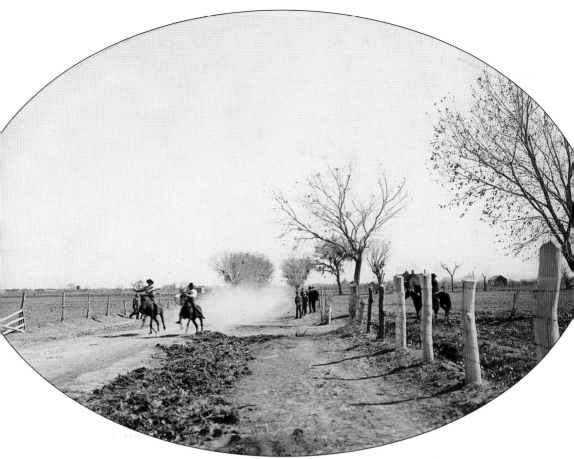

Riders and horses race down Alameda Street. These races were held every Sunday afternoon. The oval shape of the print is typical of the early Kodak type photograph. (Courtesy of NMSULASP.)

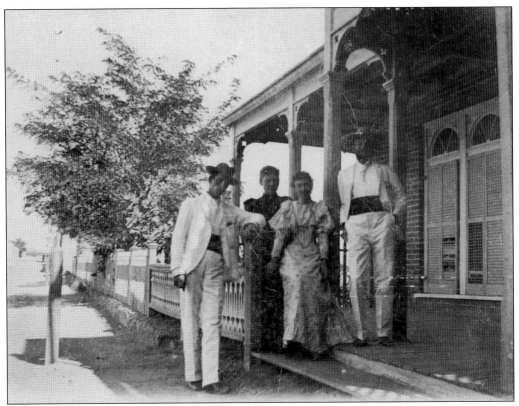

Dressed in their Sunday best, Mr. and Mrs. W.E. Baker (left) and Professor and Mrs. C.H. Tyler Townsend gather after church on April 16, 1894. (Courtesy of NMSULASP.)

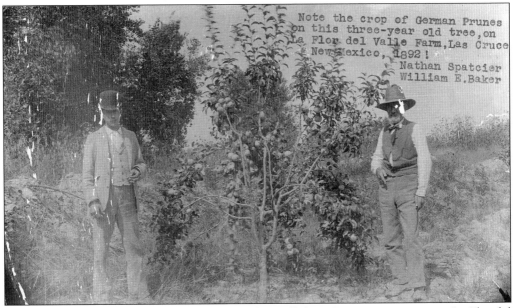

Nathan Spatcier (left) and William E. Baker show off their German prune tree at La Flor del Valle Farm in 1892. (Courtesy of NMSULASP.)

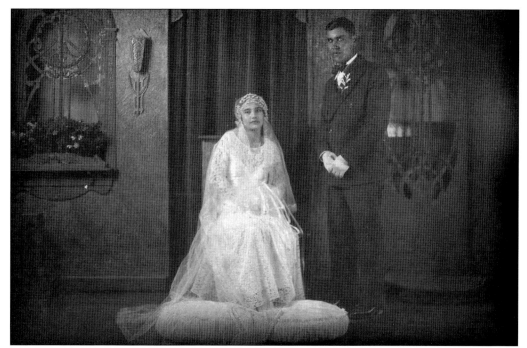

These unidentified newlyweds are sitting for their wedding photograph. The couple is clearly reflecting the old practice of not smiling for the camera. (Courtesy of NMSULASP.)

From left to right are Sadie Bowman, Charles Metcalfe and May Bowman celebrating the marriage of Sadie and Charles in this 1885 photograph. Charles worked on the local newspaper, operated a drug store and sold real estate for the Rio Grande Land Company during his time in Las Cruces. (Courtesy of NMSULASP.)

William E. Baker and Id Katzenstein pose at the Haymakers on the Alameda in 1897. (Courtesy of NMSULASP.)

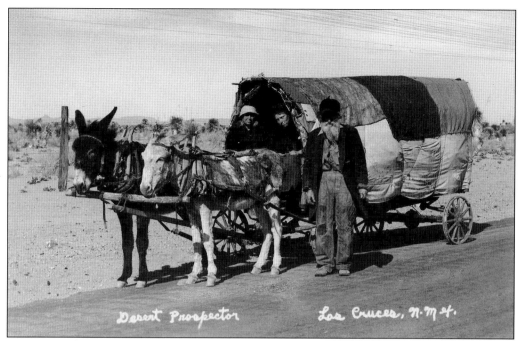

This weathered desert prospector and his family are just some of the thousands that came through southern New Mexico in the late 19th century. (Courtesy of NMSULASP.)

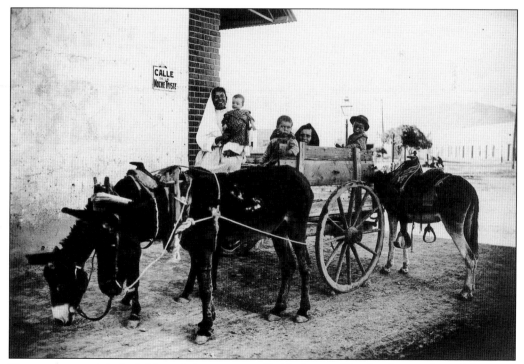

Two mothers and their children sit in a wagon pulled by burros. The family is smiling while sitting in front of a brick building with a sign that says Calle de Noche Triste or Street of the Sad Night. Another mule stands behind the wagon with large stirrups for a rider. (Courtesy of NMSULASP.)

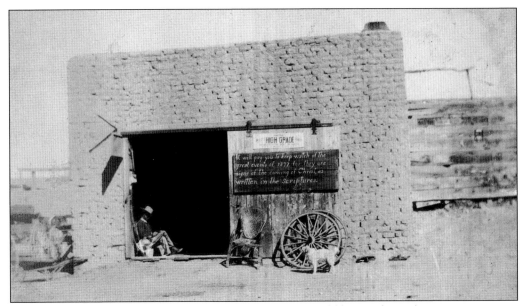

Seated outside his blacksmith shop, James H. Rynerson could be pondering his next message to Las Crucens. The current message, "It will pay you to keep up with the great events of 1897, for they are signs of the coming of Christ, as written in the Scripture," was typical of the messages the devout Bible student frequently wrote on this sign. (Courtesy of NMSULASP.)

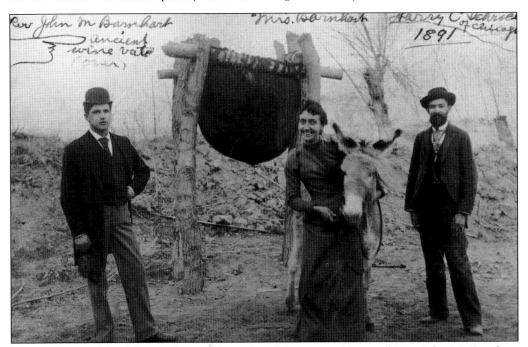

Winemaking in New Mexico dates back to the 17th century. Rev. and Mrs. John M. Barnhart of Las Cruces and their friend, Harry C. Schrock of Chicago, demonstrate how a leather wine vat is used at the Hacienda de los Carbonniere's. According to the photographer, "The grape mash was put in these vats and allowed to ferment in them and then racked off and bottled." (Courtesy of NMSULASP.)

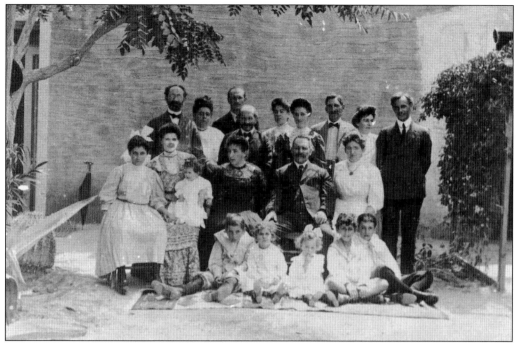

A large family poses for a photograph with the children in front and the adults in the back. (Courtesy of NMSULASP.)

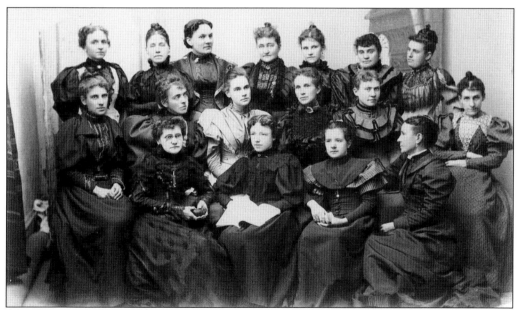

At a meeting of the Arcadian Club, members are captured in this February 20, 1895 photo. From left to right are the following: Mrs. F.W. Smith, Mrs. S.B. Newcomb, Mrs. A.L. Christy, Mrs. H.B. Holt, Mrs. F.C. Barker, Mrs. J.W. Dawson, Mrs. H.L. Miles, Mrs. Corrie Lyon, Mrs. A.E. Davidson, Mrs. E.E. Day, Mrs. A.B. Fall, Mrs. W.E. Baker, Mrs. R.S. Young, Mrs. P.H. Curren, Mrs. J. Branigan, Miss R. Macker, and Mrs. I.A. Steele. (Courtesy of NMSULASP.)

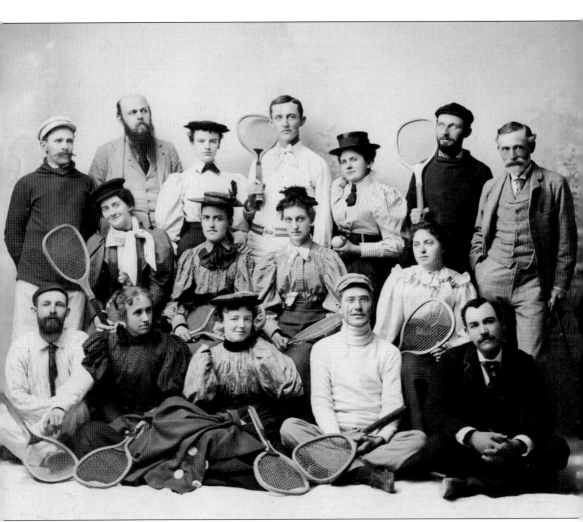

Gathering for a group photo of the Las Cruces Tennis Club in 1896, some members seem to strategize for their next match. From left to right are the following: (back row) Dr. Watson, Dr. Jordon, Miss Freeman, H.B. Holt, Miss Meade, Mr. Freeman, and F.C. Barker; (middle row) Edith Dawson, Fannie Blakesley, Miss Granger, and Millicent Barker; (front row) C.W. Ward, Katherine Stoes, Alice Branigan, Mr. Stevens, and Jack Fountain. (Courtesy of NMSULASP.)

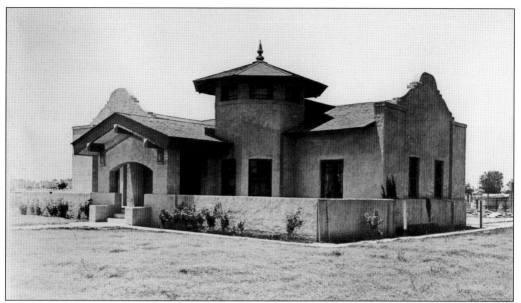

The H.B. Holt House, designed by famous architect Henry C. Trost, is a residential landmark in Las Cruces to this day. Located at the corner of Picacho and Alameda, it is an elaborate home built by H.B. Holt, a prominent lawyer, banker, and a member of the Las Cruces Tennis Club. (Courtesy of NMSULASP.)

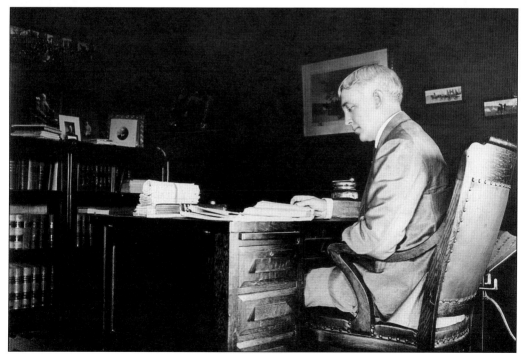

Here H.B Holt sits at his desk. Holt was an influential attorney and a banker in Las Cruces in the 1910s and the 1920s. He was president of First National Bank in 1928, a member of the New Mexico A&M Board of Regents, a New Mexico state legislator, and a candidate from New Mexico for a U.S. Senate seat. (Courtesy of NMSULASP.)

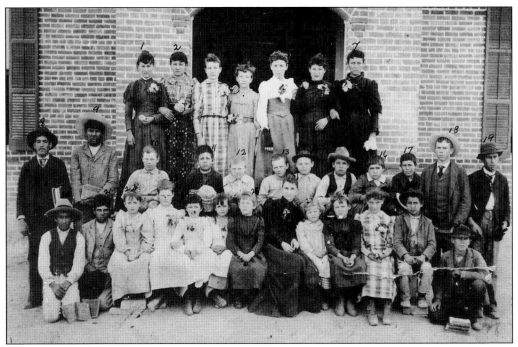

Children gather for their 1894–1895 grade school photo at an unidentified educational institution. (Courtesy of NMSULASP.)

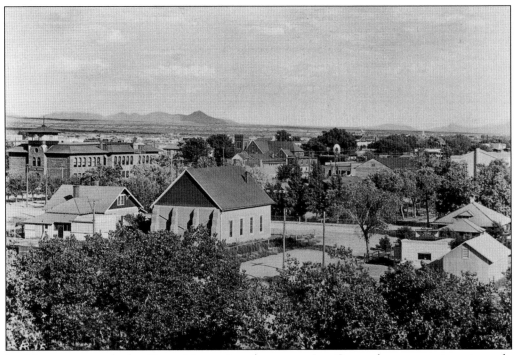

Looking east towards the Organ Mountains, downtown Las Cruces has grown since its early days. The building on the center left of the photograph is the Central Public School on Las Cruces Avenue. (Courtesy of NMSULASP.)

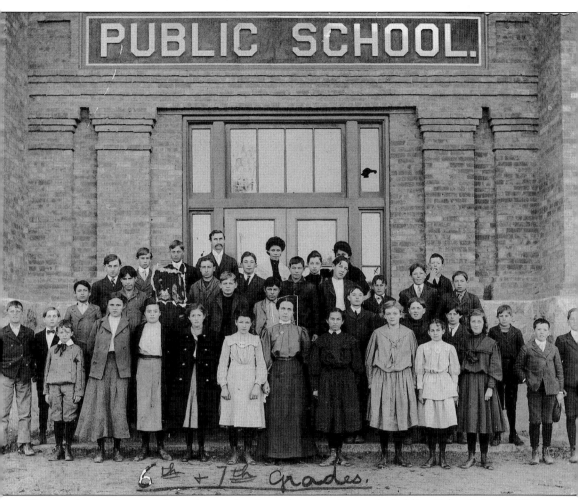

The sixth- and seventh-grade graduating class at Central Public School in 1907. (Courtesy of NMSULASP.)

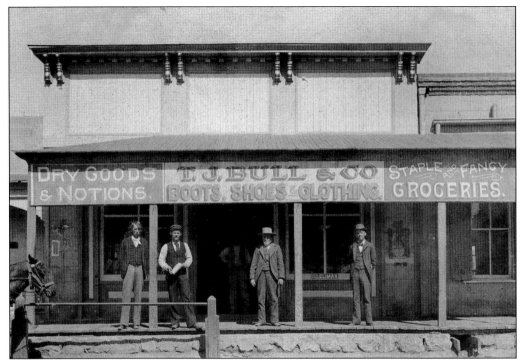

Four unidentified employees pose in front of the T.J. Bull & Co. Store on Main Street. (Courtesy of NMSULASP.)

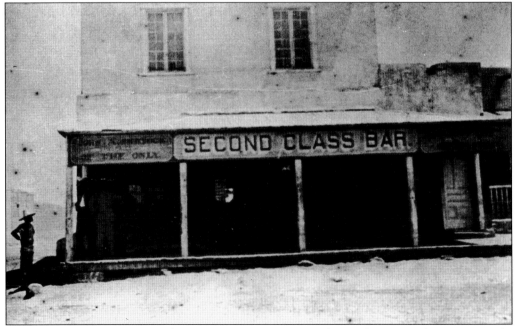

The Second Class Bar is open for business on Main Street around 1900. (Courtesy of NMSULASP.)

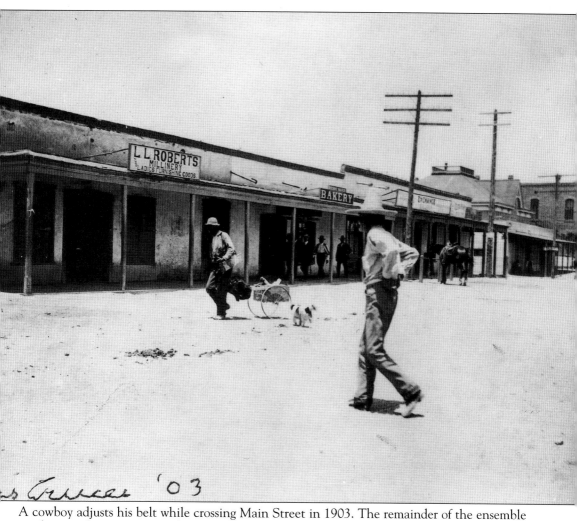
A cowboy adjusts his belt while crossing Main Street in 1903. The remainder of the ensemble needs no such maintenance. (Courtesy of NMSULASP)

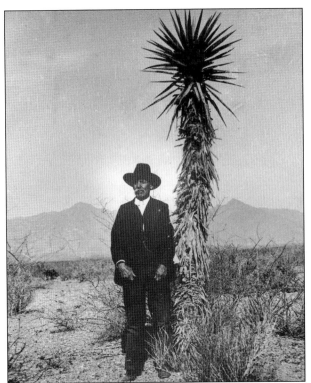

Col. Eugene Van Patten became county sheriff in 1884 and helped with the construction of Loretto Academy. He homesteaded the Dripping Springs area 20 miles east of Las Cruces in the Organ Mountains in the early 1890s, where he developed a resort that eventually became a tuberculosis sanitarium. Van Patten sold the Dripping Springs sanitarium in 1917. (Courtesy of NMSULASP.)

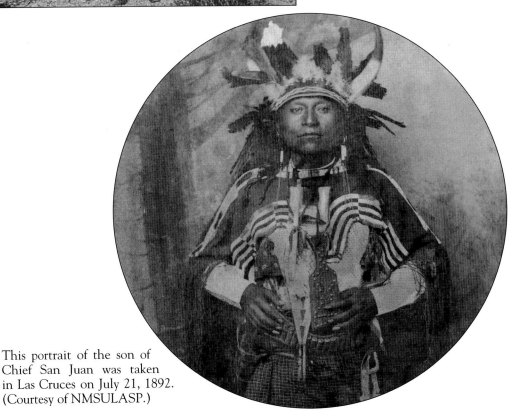

This portrait of the son of Chief San Juan was taken in Las Cruces on July 21, 1892. (Courtesy of NMSULASP.)

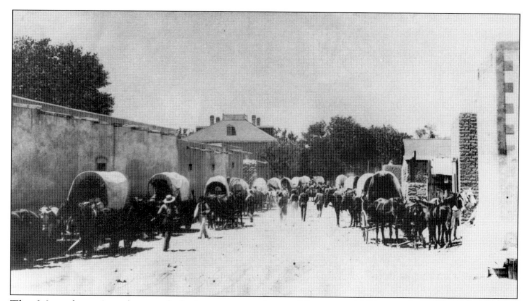

The Mescalero Apaches and their wagons, pictured here in 1889, used to travel over 100 miles from their reservation to trade at Martin Lohman's shop on the corner of Depot and Main. Lohman's store is pictured to the left and Schenk's Bakery and Grocery is visible to the right. (Courtesy of NMSULASP.)

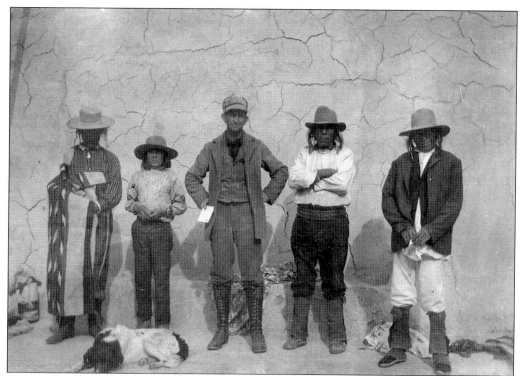

William Coleman Martin poses with Apaches in front of a building on Main Street in 1906. (Courtesy of IHSF.)

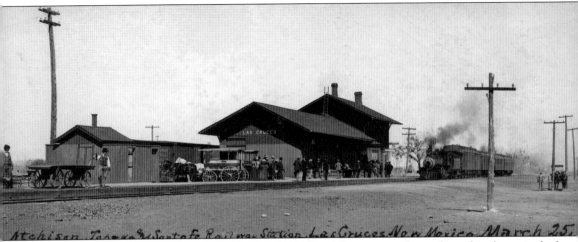

This wooden Atchison, Topeka and Santa Fe railroad depot greeted travelers after the arrival of the railroad in 1880 and before the construction of the new depot around 1910. This 1901 picture shows the station seen from Depot Street, later renamed Las Cruces Avenue. Originally built in 1881, this depot was later moved to Anthony, New Mexico. (Courtesy of NMSULASP.)

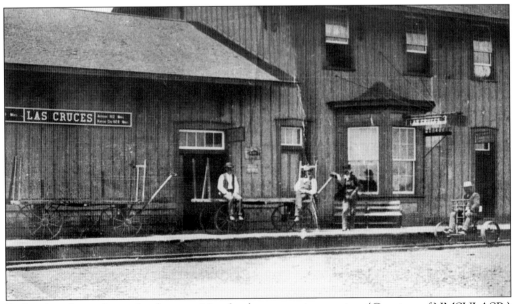

Railroad workers relax at the depot waiting for the next train to arrive. (Courtesy of NMSULASP.)

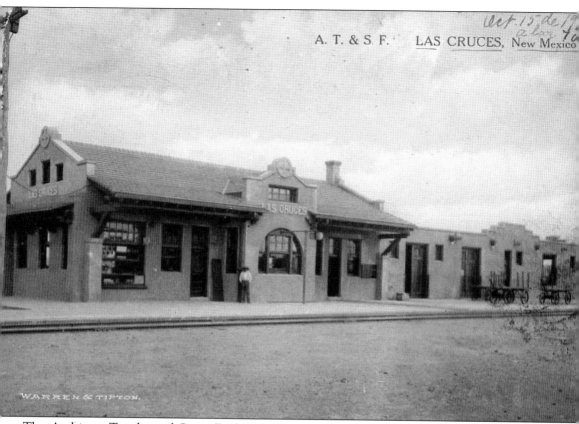

The Atchison, Topeka and Santa Fe (AT&SF) railroad completed a new depot in 1910 at the site of the old depot. Designers constructed the Mission Revival-style depot. Also as an improvement, the city paved Las Cruces Avenue, which ran from the station seven blocks east to Main Street. This was the first paved street in town so that people arriving on the train would have a good first impression of Las Cruces. (Courtesy of NMSULASP.)

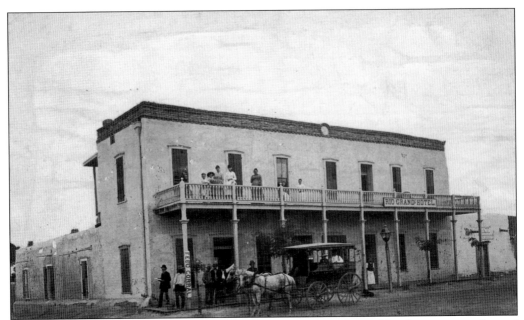

Located on Main Street, the Rio Grande Hotel was one of Las Cruces' first businesses to depend largely on railroad patrons. The three women standing on the top balcony, from left to right, are Annie May, Amelin May, and Elizabeth May (who owned and operated the hotel in 1887 when this photo was taken). This hotel was unique since few women owned their own businesses in the late 19th century. (Courtesy of NMSULASP.)

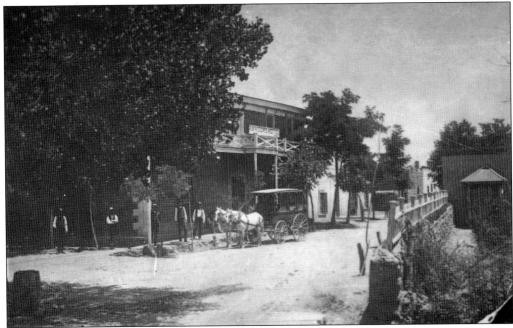

Competing with the Rio Grande Hotel, the Amador Hotel also depended on the railroad for patrons. Note the grand carriage that the Amador Hotel used to transport visitors from the railroad depot to their establishment. (Courtesy of NMSULASP.)

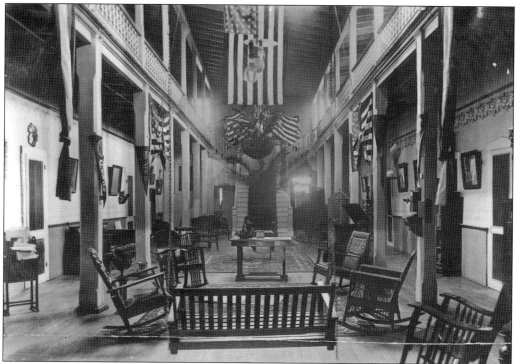

This postcard shows the interior of the Amador Hotel, with large flags greeting the guests. The Amador Hotel was located at Amador Avenue and Water Street and is currently the Doña Ana County Manager's Complex. This photograph was taken on October 7, 1916. (Courtesy of NMSULASP.)

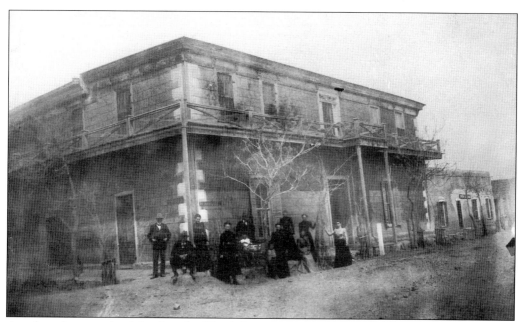

Another photograph of the Amador Hotel shows a group of unidentified people in front posing for the camera. (Courtesy of NMSULASP.)

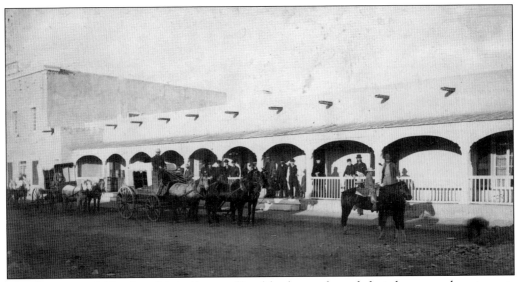
The Commercial Hotel on Main Street offered both people and their horses a place to rest. (Courtesy of NMSULASP.)

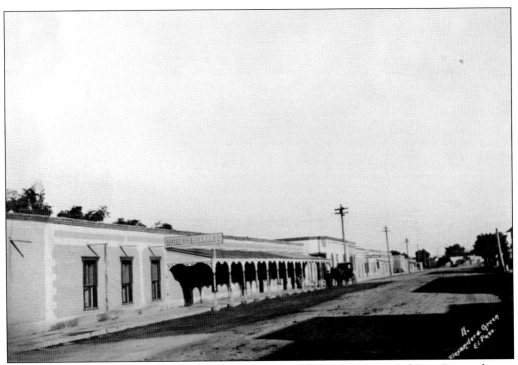
Built by Louis E. Fruedenthal to compete with the Amador Hotel, the Hotel Don Bernardo was remodeled a number of times over the years. In the "good old days" for $2 guests got a room, a meal, and a corral for a horse. The Hotel Don Bernardo featured a covered walkway to protect its guests from the harsh southwestern sun. (Courtesy of NMSULASP.)

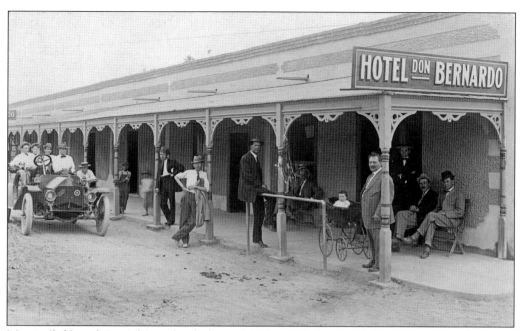

Morris (left) and Daniel Freudenthal stand in front of the Hotel Don Bernardo, which was owned by the Freudenthal family. The Hotel Don Bernardo was located on North Main Street. (Courtesy of NMSULASP.)

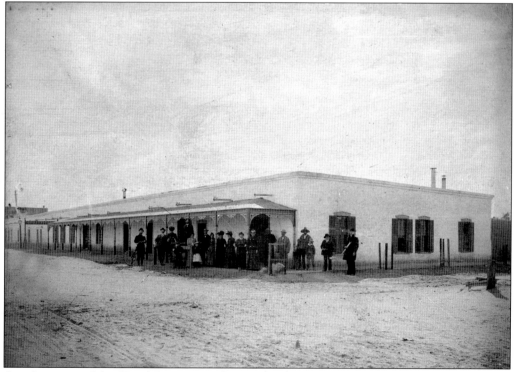

Another view of the Hotel Don Bernardo in 1924 shows that it was a popular destination on North Main Street. (Courtesy of NMSULASP.)

The Acequia Madre, the main irrigation ditch, transported the vital water from the Rio Grande into town for both domestic as well as agricultural uses. It is pictured here in 1900. (Courtesy of NMSULASP.)

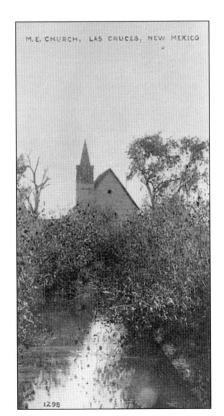

The Acequia, flanked by thick brush, ran past St. Paul's Methodist Episcopal Church on the corner of Alameda and Griggs Streets. (Courtesy of NMSULASP.)

Two
EARLY 20TH CENTURY IN THE CITY OF CROSSES

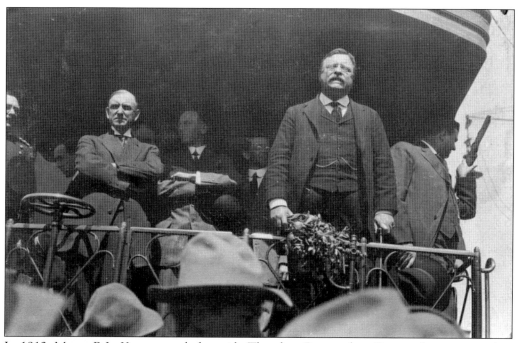

In 1912, Mayor R.L. Young stood alongside Theodore Roosevelt as Roosevelt campaigned in Las Cruces. Roosevelt probably passed through the state in late September or early October on his way to California. (Courtesy of NMSULASP.)

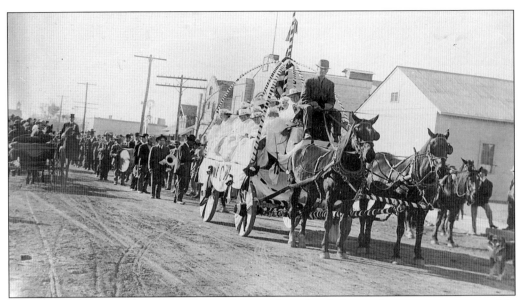
A festive float leads a parade complete with a marching band along a downtown street, possibly Church Street. (Courtesy of IHSF.)

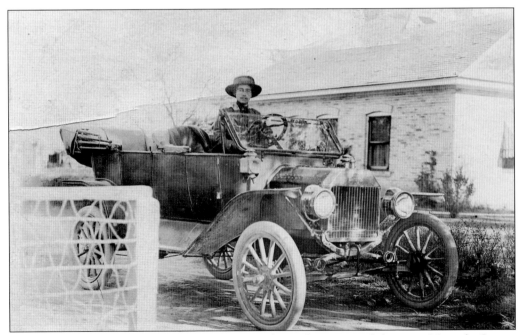
Contrary to the norms of the day, a woman drives her automobile onto Miranda Street. (Courtesy of IHSF.)

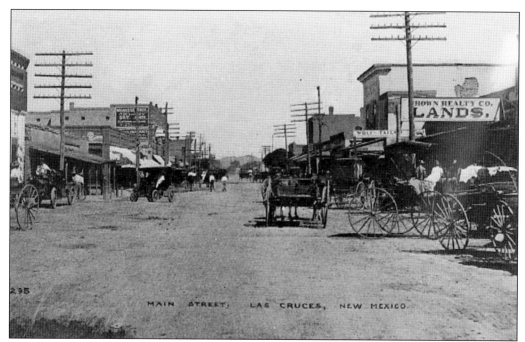

This photograph shows Main Street in the 1910s when horses and buggies were the transportation of choice. (Courtesy of IHSF.)

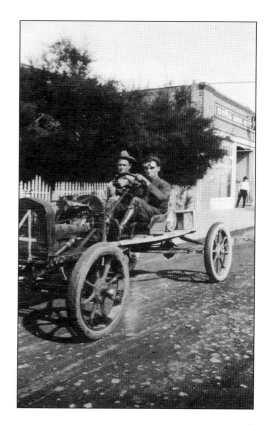

On this day out in the sun, Sid Mowad (left) and Alex Hood pose for a picture sitting in a racecar. The picture was taken on Miranda Street, which was a long road with few obstacles—perfect for a Sunday drive. (Courtesy of IHSF.)

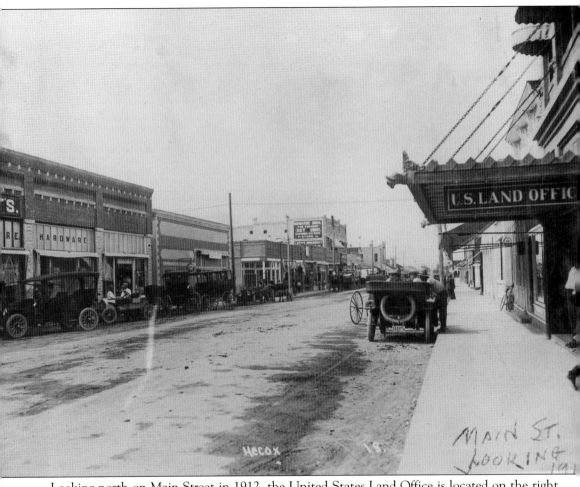

Looking north on Main Street in 1912, the United States Land Office is located on the right side. A wide variety of cars, including a "Ford Model A" automobile on the left, have replaced the horses and buggies of only a few years before. (Courtesy of NMSULASP.)

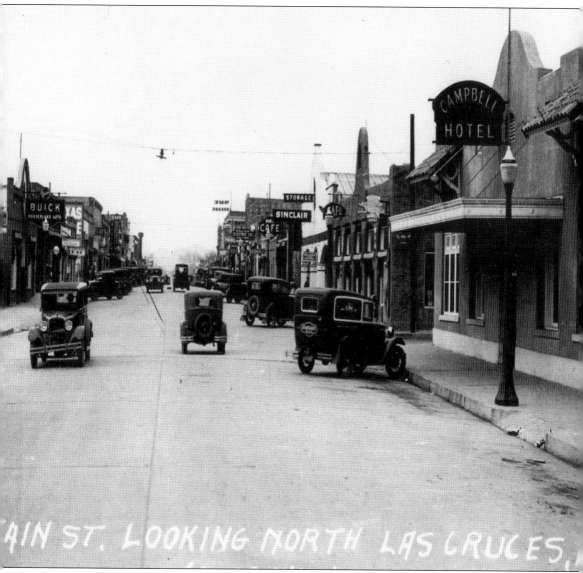

Further down Main Street, looking north, businesses are located throughout the area. The paved road made it easier for customers to maneuver quickly and efficiently to businesses such as the Sinclair and Refining Company, managed by Pierce Hubbard, and the Campbell Hotel owned by Laura and T.C. Campbell. (Courtesy of IHSF.)

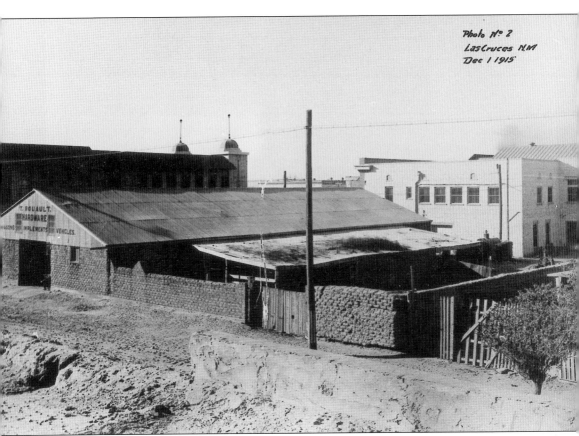

On December 1, 1915, the Masonic Temple with its distinctive steeples was a vital part of the downtown scene. The Temple was located on 130 East Griggs at the corner of Griggs and Church Streets, opposite from what was then the post office. (Courtesy of NMSULASP.)

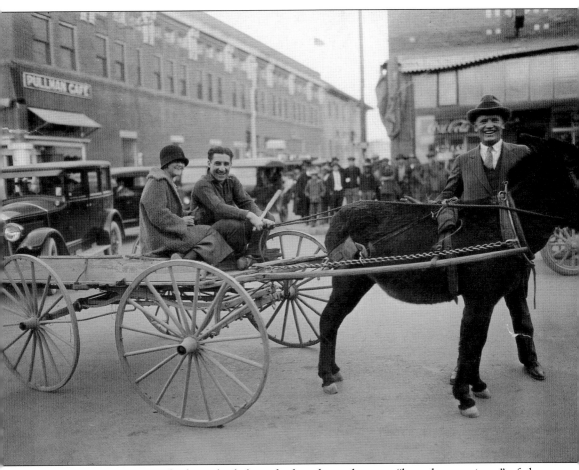

Many in Las Cruces might have had their doubts about the new "horseless carriages" of the 1910s, but this couple most likely just seized the opportunity to take a romantic burro ride down Main Street past the Hotel Rouault on the left. (Courtesy of NMSULASP.)

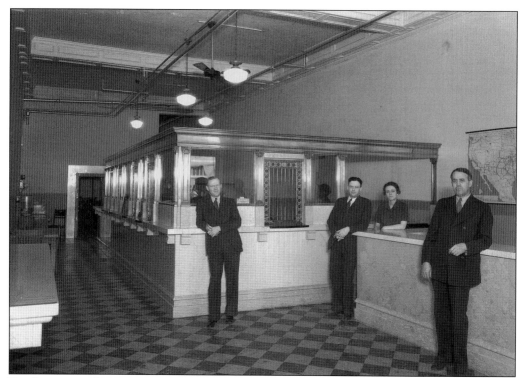

Employees pose for a picture on a slow day at the First National Bank in 1914. The First National Bank was founded in 1905 when Nathan Body outbid Henry Bowman to win federal authorization of the first nationally chartered bank in the territory. (Courtesy of NMSULASP.)

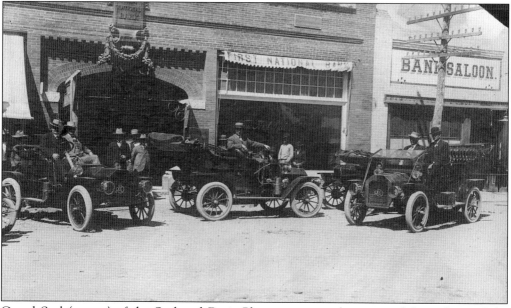

Carrol Seal (center) of the Seal and Dyrie Pharmacy sits in his automobile in front of the First National Bank Building in 1910. Carrol is flanked by some unidentified companions. (Courtesy of NMSULASP.)

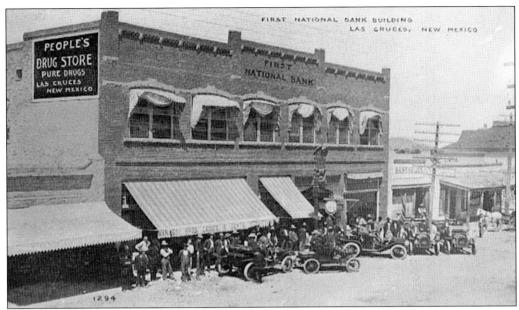

The First National Bank, located on 131 North Main Street, offered plenty of parking for its customers. Advertised on the side of the bank is the People's Drug Store, also located on North Main Street. This photograph was taken on June 21, 1909. (Courtesy of IHSF.)

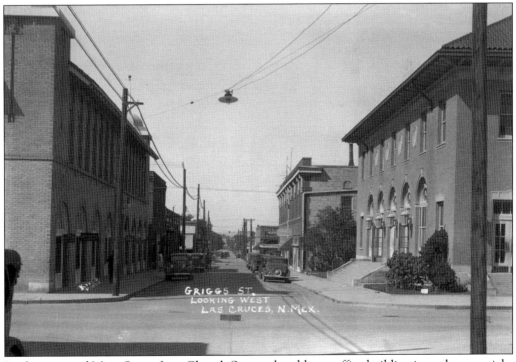

Looking toward Main Street from Church Street, the old post office building is on the near right with the Hotel Herndon immediately behind it. Hotel Rouault, seen on page 53, later became Hotel Herndon. (Courtesy of NMSULASP.)

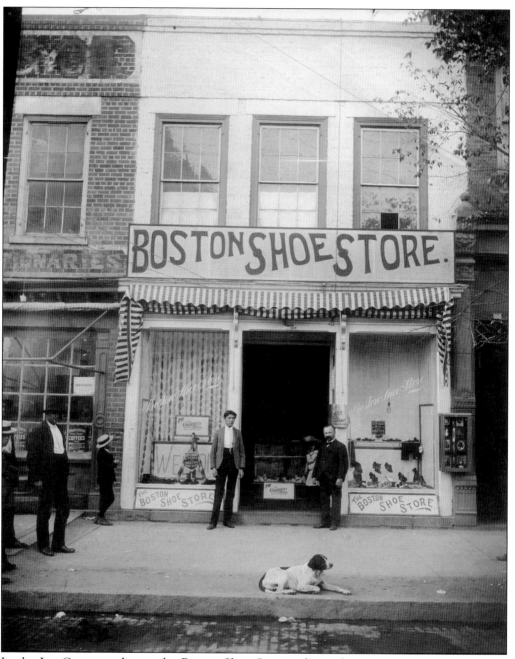

In the Las Cruces tradition, the Boston Shoe Store welcomed man and beast (in this case, humans and dogs) alike. (Courtesy of NMSULASP.)

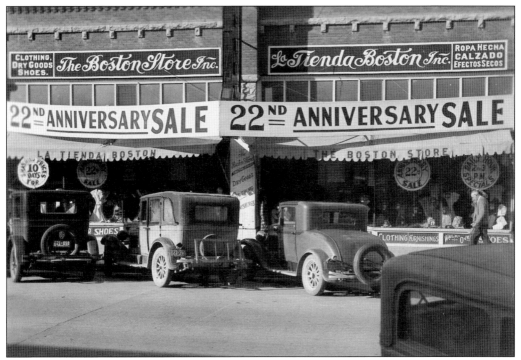

The Boston Shoe Store on South Main is shown celebrating its 22nd anniversary. The Boston Shoe Store sold clothing, dry goods, and shoes. Note the bilingual sign announcing the sale. (Courtesy of NMSULASP.)

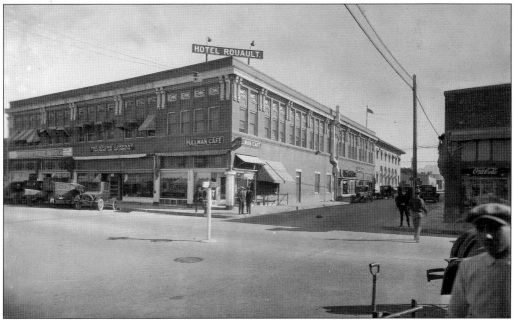

The Hotel Rouault was at the corner of Main and Griggs Streets Down the block on the right, the old post office can be seen. The old post office now holds the municipal court house. (Courtesy of NMSULASP.)

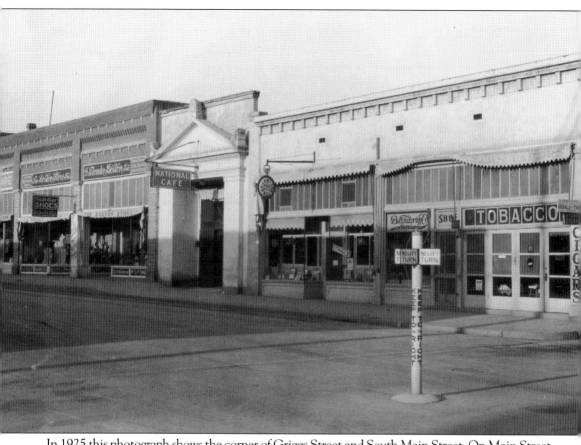

In 1925 this photograph shows the corner of Griggs Street and South Main Street. On Main Street, the E.T. Johns Cigars and Newsstand and the National Café were next to the Boston Shoe Store. In the middle of the intersection, a street sign directs traffic. (Courtesy of NMSULASP.)

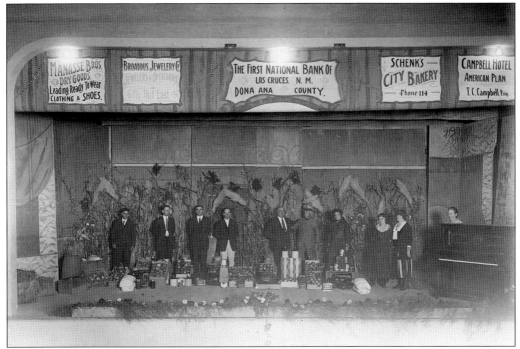

The Armory and Opera House on West Griggs held a Harvest Home Scene sponsored by the First National Bank. Local businesses such as Manesse's Dry Goods (which sold ready to wear clothing and shoes), the Campbell Hotel, Schenk's City Bakery, the First National Bank, and the Broadous Jewelry store advertised at the event. (Courtesy of NMSULASP.)

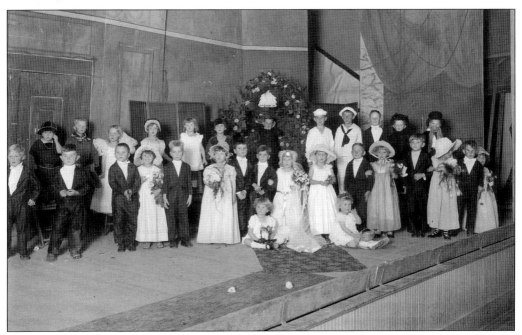

Another event held at the Armory and Opera House was a Tom Thumb Juvenile Wedding around 1920. (Courtesy of NMSULASP.)

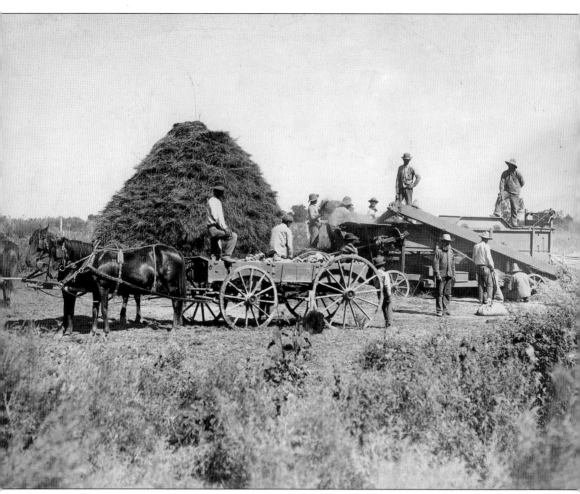

Over the years, cotton, onions, pecans, and chili have been agricultural staples in the Las Cruces area. The Elephant Butte Dam built by the Bureau of Reclamation north of Truth or Consequences contributed to the availability of water for the Las Cruces farming season. Beginning in 1916, the massive irrigation project released water that made the Mesilla Valley an agricultural oasis. (Courtesy of NMSULASP.)

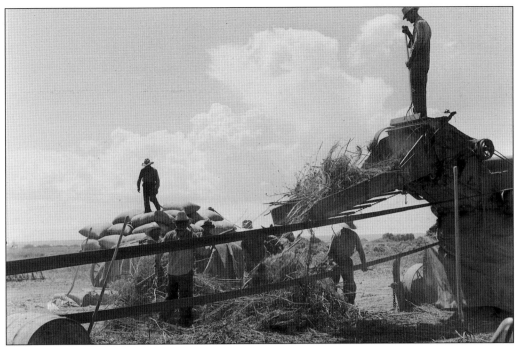

Agriculture workers delivered a cut crop, most likely alfalfa or hay, to the hopper. Note the long belt that powers the device. (Courtesy of NMSULASP.)

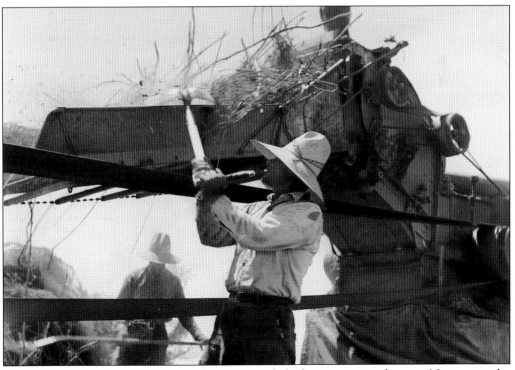

Here a laborer loads cut crops onto the conveyor belt that goes into a hopper. Note again the long drive belt that powers the machinery. (Courtesy of NMSULASP.)

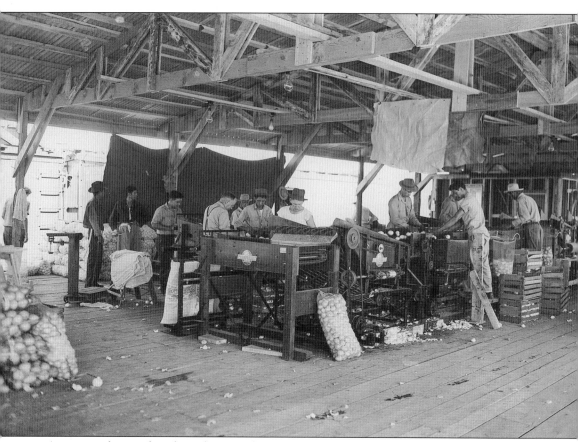

A group of agricultural workers grade onions, a staple crop in the Mesilla Valley since Elephant Butte Dam created a reliable source of water during the growing season. (Courtesy of NMSULASP.)

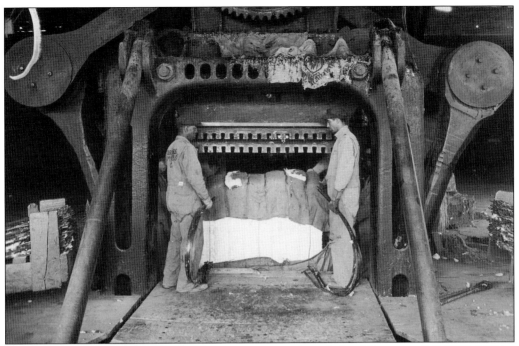
This compress shaped and compacted loose cotton into dense bales. (Courtesy of NMSULASP.)

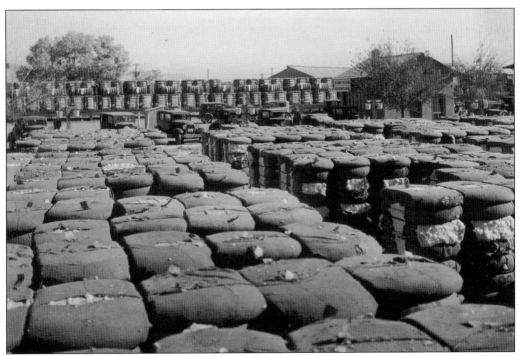
After being compressed, these bales of cotton are ready to be loaded onto railroad cars. (Courtesy of NMSULASP.)

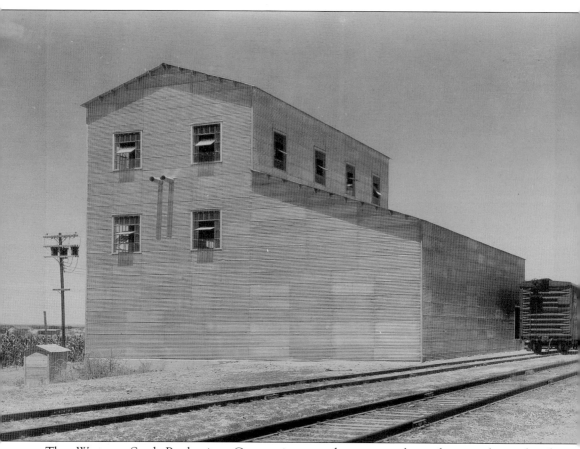
The Western Seed Production Corporation warehouse was located near the railroad tracks to facilitate loading product onto rail cars for delivery throughout the nation. (Courtesy of NMSULASP.)

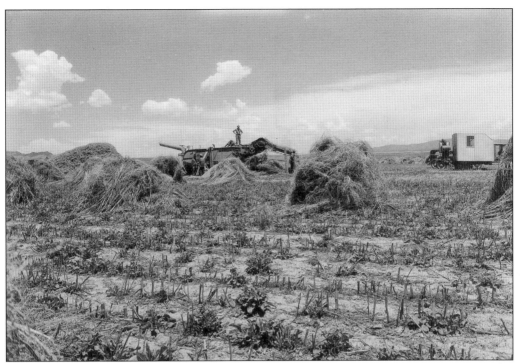

The crops were close cut, leaving a minimum of stubble to be plowed under for future crops. (Courtesy of NMSULASP.)

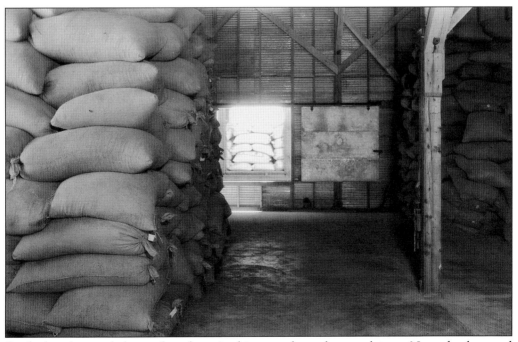

Stacked and tagged, bags of seed await shipment from the warehouse. Note the louvered construction of the sides of the building to allow freer circulation of air inside the building. (Courtesy of NMSULASP.)

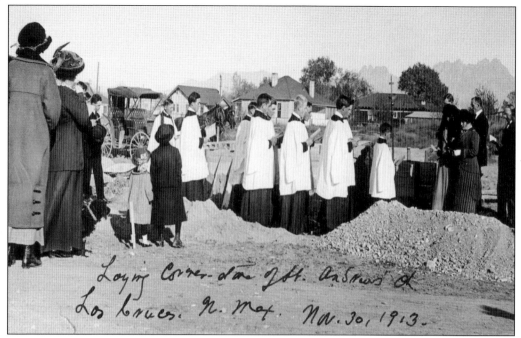

St. Andrew's Episcopal Church was chartered on November 30, 1913. Parishioners gather around as the cornerstone was laid. Prior to the present name, the church was called St. Andrew's Memorial Church. The church is located at its original site on 518 North Alameda. (Courtesy of IHSF.)

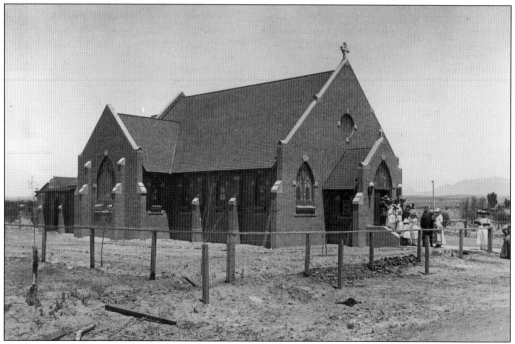

St. James' Episcopal Church on South Main Street was the home church for Reverend Lewis. (Courtesy of NMSULASP.)

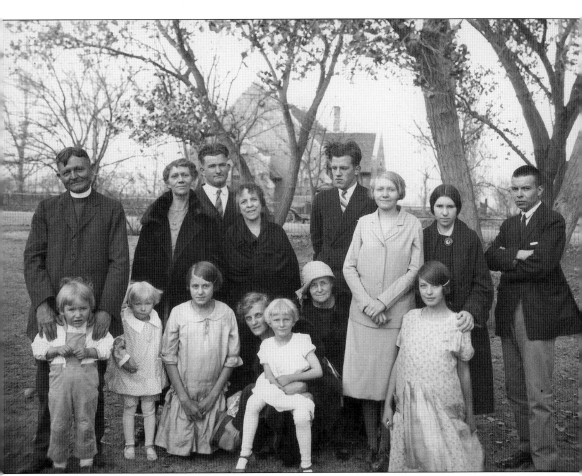

Reverend Lewis (far left), pictured here with his family, administered to the Episcopal faithful of southern New Mexico. Servicing his 21 parishes from La Union to Socorro and out to Silver City, he often walked to them with nothing but a communion kit bedecked in reflective tape to protect him during his nocturnal highway strolls. (Courtesy of NMSULASP)

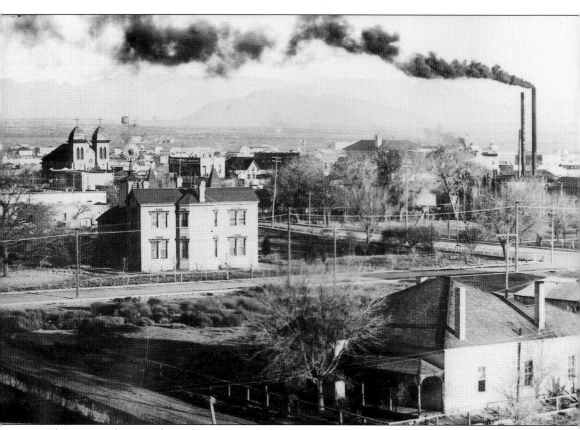
The power plant on the right generated electricity for Las Cruces. St. Genevieve's Church on the left was the focal point of a vibrant downtown. Looking east, the Tortugas Mountain and the Organ Mountains serve as backdrops to the Mesilla Valley. (Courtesy of NMSULASP)

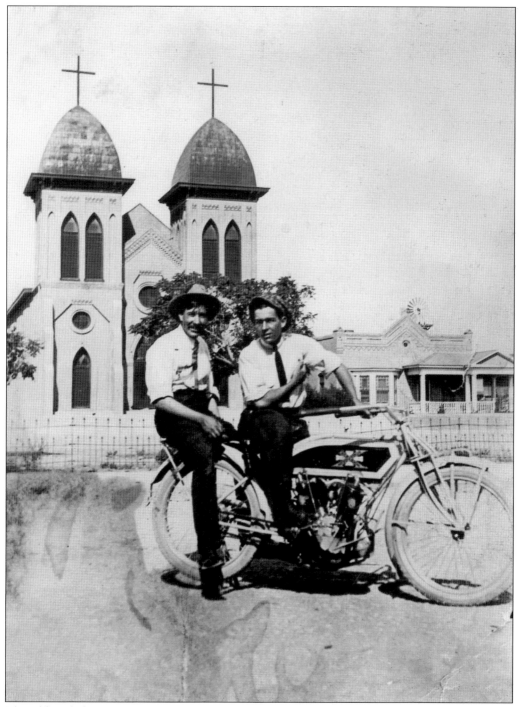

The old and the new meet in Las Cruces. Mounted on a new motorcycle, these fellows are shown in front of the old St. Genevieve's Church. (Courtesy of NMSULASP.)

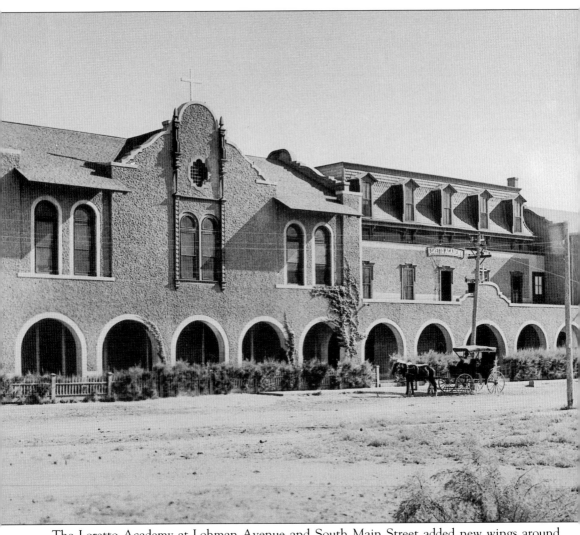

The Loretto Academy at Lohman Avenue and South Main Street added new wings around 1915. Henry C. Trost was the original architect of the Spanish Mission-style Loretto Academy, a Catholic school for girls. (Courtesy of NMSULASP.)

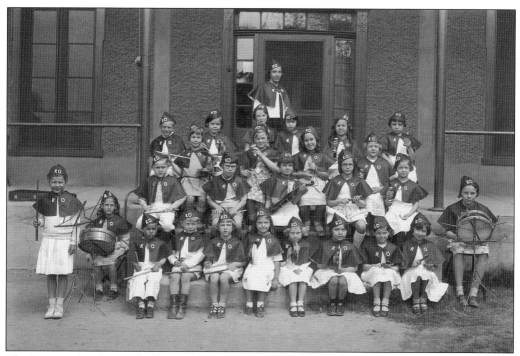
The Loretto Academy Rhythm Orchestra in the spring of 1933 consisted of both boys and girls sporting capes and caps. Snare drums, triangles, woodblocks, and a variety of other instruments set toes a-tapping. (Courtesy of NMSULASP.)

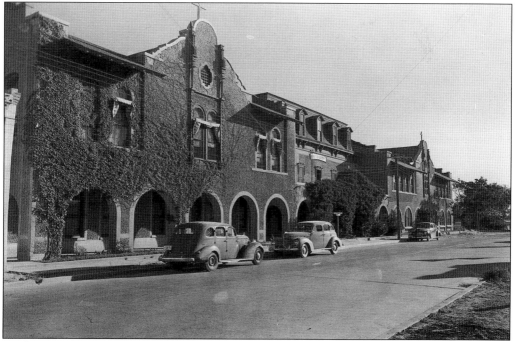
At the southern end of Main Street, the imposing Loretto Academy ran for several blocks along Lohman Avenue. (Courtesy of NMSULASP.)

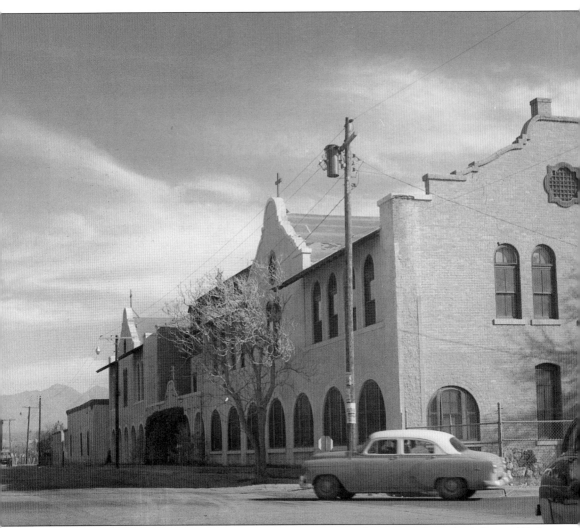

The Sisters of Loretto taught in Las Cruces from 1870 until 1943. Built at the behest of Bishop John Baptist Lamy, Loretto Academy was an effort to "Americanize" the people of New Mexico. In 1880, Sister Praxedes Carty became mother superior. Under her dynamic leadership, the school flourished and was involved with a number of activities in the Catholic community, including the restoration of St. Genevieve's Church in 1886. (Courtesy of NMSULASP.)

Reverend Hoyle's Baptist Church at 106 South Miranda Street is pictured here on June 10, 1933. The church still stands, though it has been expanded considerably, and today the building seen here serves solely as the Sunday school. (Courtesy of NMSULASP.)

This church served Las Cruces during the Great Depression. (Courtesy of NMSULASP.)

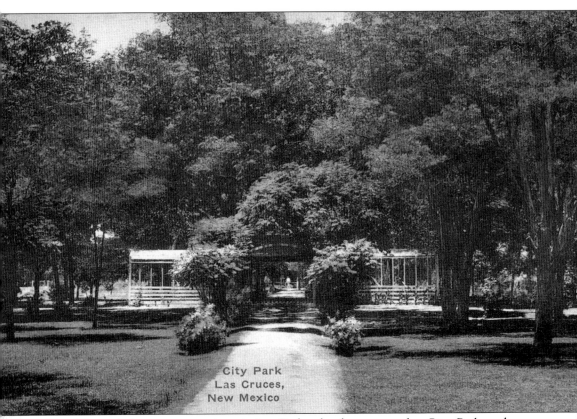

The Women's Improvement Association Park, also known as the City Park and now as Pioneer Park, had a large gazebo and a lush green landscape. This photograph is the front of a hand-colored postcard. The park was located across the street from the Women's Improvement Association Building (W.I.A.) and south of the Park Hotel. (Courtesy of NMSULASP.)

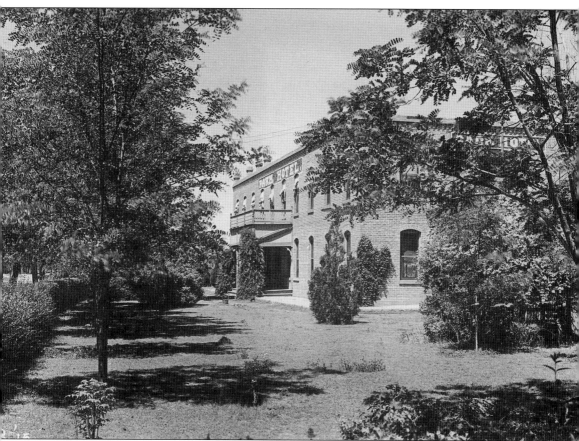

Prior to its demolition, the Park Hotel on Court Avenue was a prime destination for visitors to Las Cruces. It was located northwest of the W.I.A. park, which is now Pioneer Park. (Courtesy of NMSULASP.)

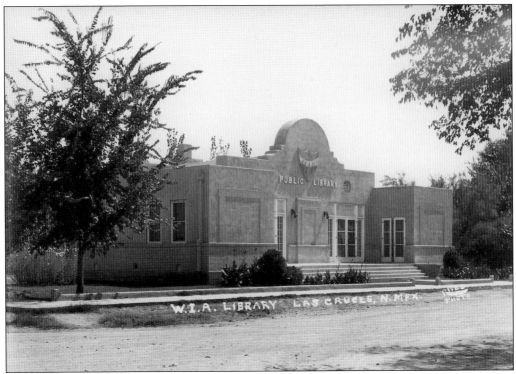

The W.I.A. also operated the first public library in Las Cruces out of this building. (Courtesy of NMSULASP.)

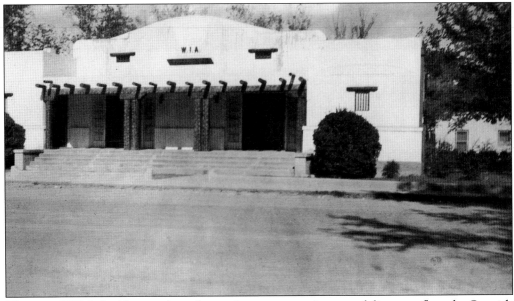

The same W.I.A. building as above has undergone extensive remodeling to reflect the Spanish Colonial-Pueblo Revival style popular in the 1920s. (Courtesy of NMSULASP.)

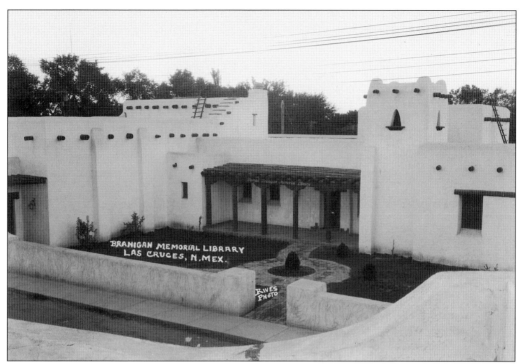

The Thomas Branigan Memorial Library, on North Main Street, was also built in the Spanish Colonial-Pueblo Revival style. After its completion in 1935, it was dedicated to Capt. Thomas Branigan, a Las Cruces bee farmer whose estate was donated by his wife, Alice, to fund library operations. (Courtesy of NMSULASP.)

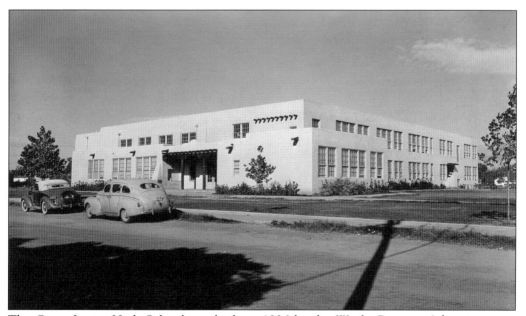

The Court Junior High School was built in 1936 by the Works Progress Administration. This place is still a cherished building for the many Las Cruces adults who attended school there. (Courtesy of NMSULASP.)

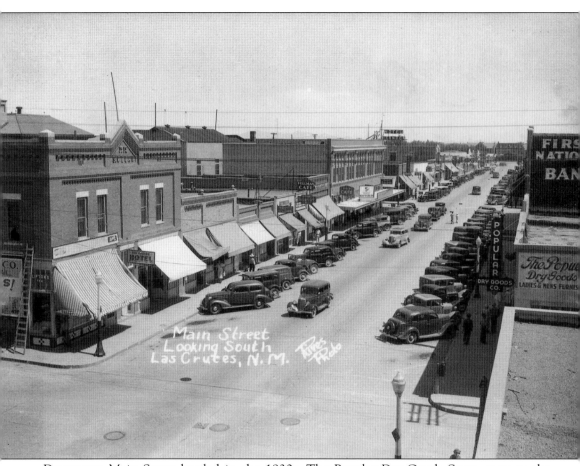

Downtown Main Street bustled in the 1930s. The Popular Dry Goods Store, seen to the right, offered Las Cruces citizens a variety of essentials up until it closed in the late 1990s. (Courtesy of NMSULASP.)

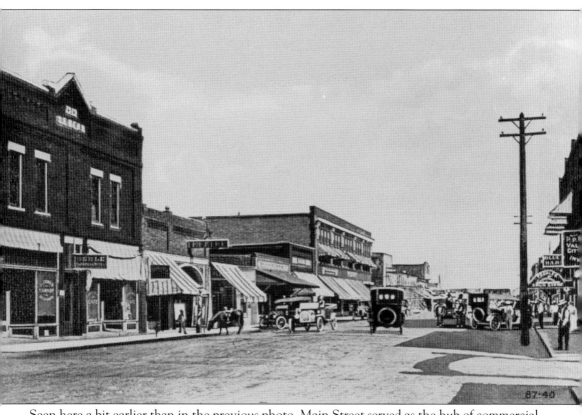

Seen here a bit earlier than in the previous photo, Main Street served as the hub of commercial and social activity throughout the first half of the 20th century. (Courtesy of NMSULASP.)

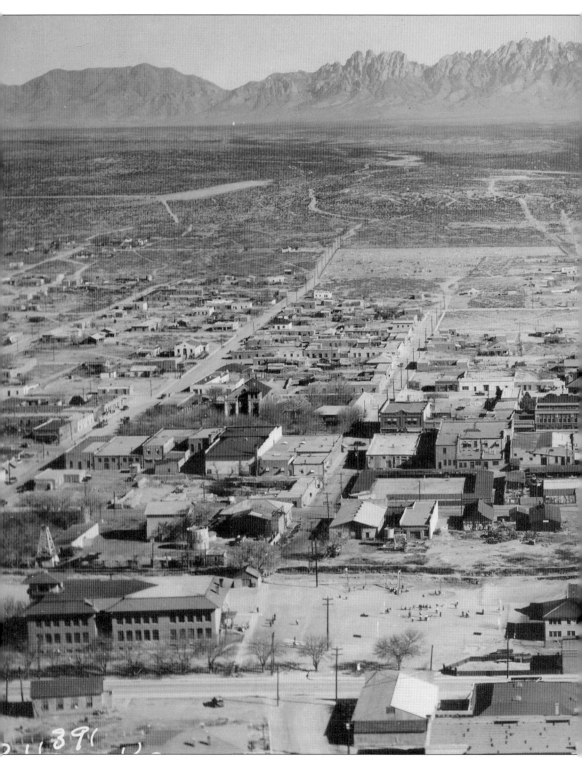

This aerial view of Las Cruces shows the unpaved streets of the downtown district of the 1930s. Note St. Genevieve's spires on the left as they undergo renovation to reduce their height. In the

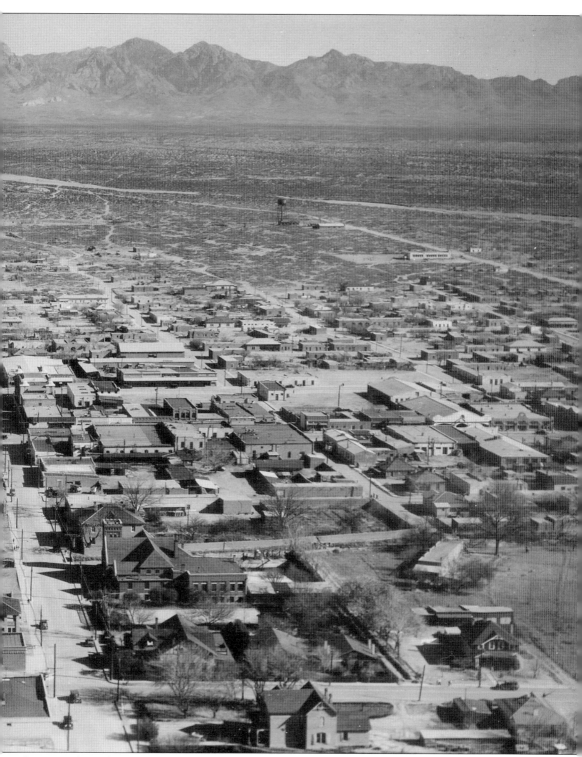
foreground are the students from Central School out for a recess. (Courtesy of IHSF.)

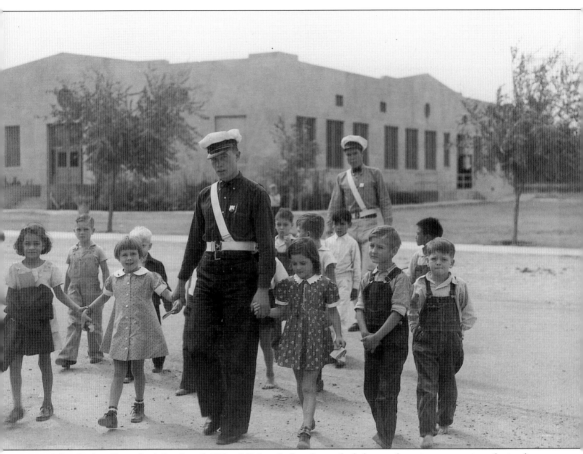

The Safety Patrol of the South Ward School clearly prided themselves in protecting their charges. The rural nature of the community is evident in this 1939 photo, in which several of the children are coming to school bare-footed. The white hats and belts of the adults, along with their badges, indicate the seriousness with which they undertook their jobs. (Courtesy of NMSULASP.)

Three
THE DEPRESSION, WORLD WAR II, AND A RETURN TO PEACE AND PROSPERITY

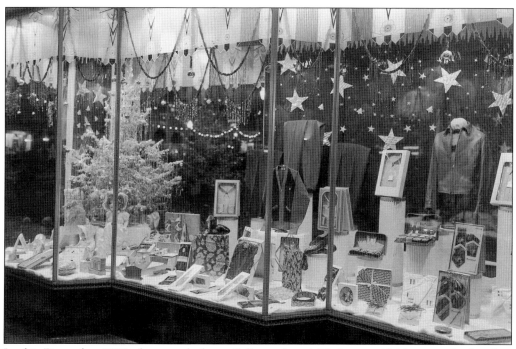

In this December 1939 photograph, beautifully packaged Christmas gift ideas are displayed in the window of the United Store on Main Street. (Courtesy of NMSULASP.)

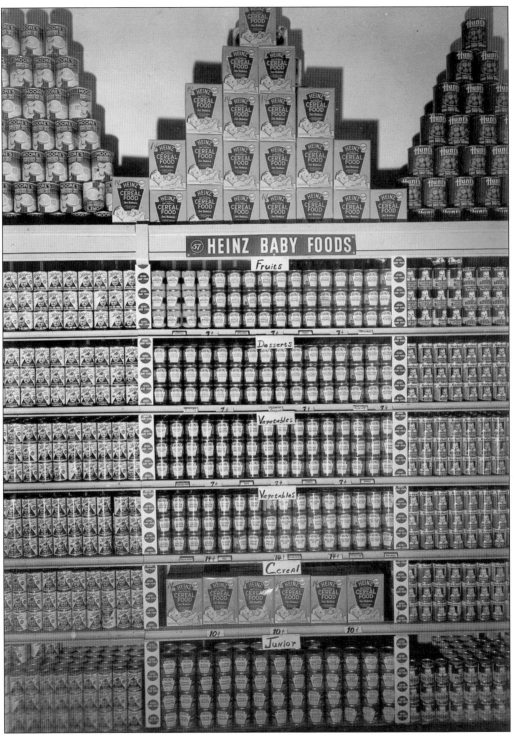

Fruits, desserts, vegetables, and cereal await shoppers in a grocery store in Las Cruces in the 1940s. Processed baby food, a relatively new product, is seen in this well-stocked Heinz Baby Foods display. (Courtesy of NMSULASP.)

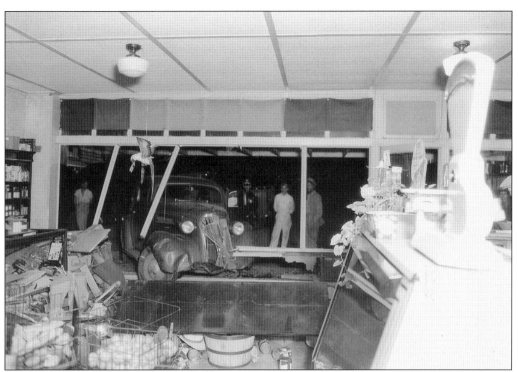

This car crash into the Carpenter's Store in September 1937 was photographed for insurance purposes by Ballard's photo studio. (Courtesy of NMSULASP.)

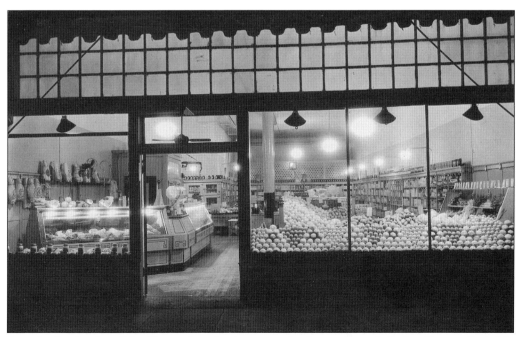

Even in the depths of the Depression, food seems to be in good supply in Las Cruces. Probably requiring a time-elapsed exposure to illuminate the interior of this market, this night-time photo, c. 1934, features creative displays and full shelves. (Courtesy of NMSULASP.)

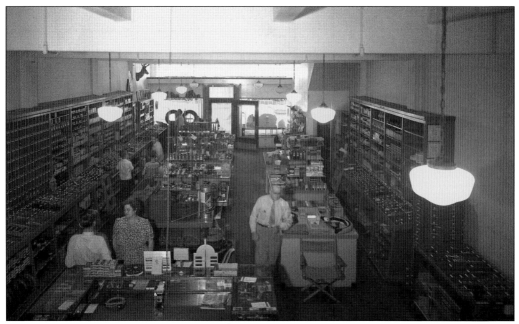

Another fully stocked store caters to all age groups. (Courtesy of NMSULASP.)

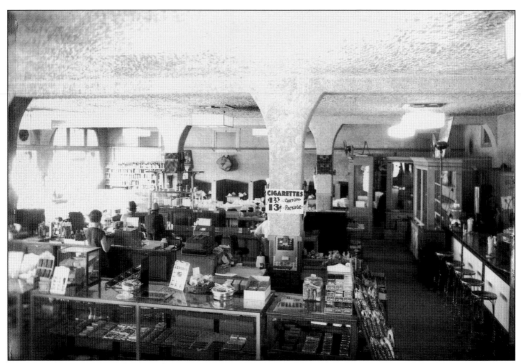

A notions store, complete with a soda fountain bar on the right and a variety of tobacco products, caters to shoppers. (Courtesy of NMSULASP.)

A car owner goes over his repair bill with a local automobile mechanic. (Courtesy of NMSULASP.)

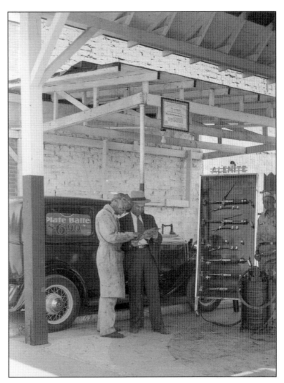

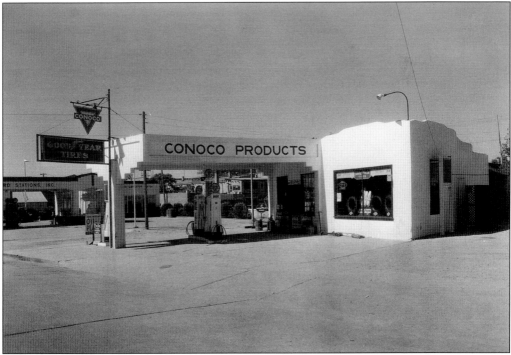

In the halcyon days of full service, uniformed gas station attendants serviced customers' cars. This photo was taken on July 14, 1941 at the Conoco Service Station No. 1 at 305 North Main. (Courtesy of NMSULASP.)

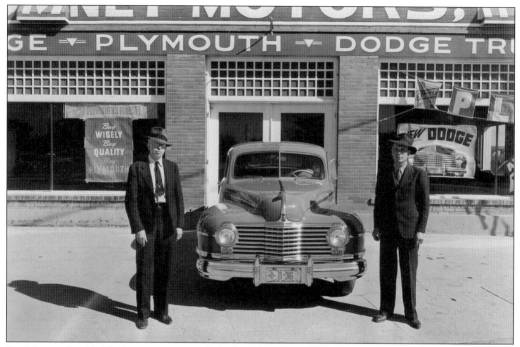

On November 7, 1941, just one month before Pearl Harbor, G.M. and Keith Romney proudly pose with a new Dodge automobile at Romney Motors, Inc., located at 401 South Alameda. (Courtesy of NMSULASP.)

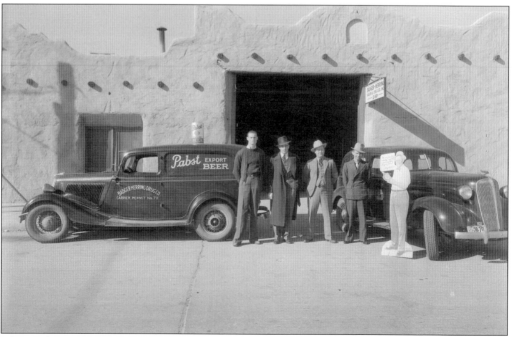

The Badger Herring Drug Company distributed Pabst Blue Ribbon Beer out of this adobe warehouse. Note the giant beer can on top of the car. (Courtesy of NMSULASP.)

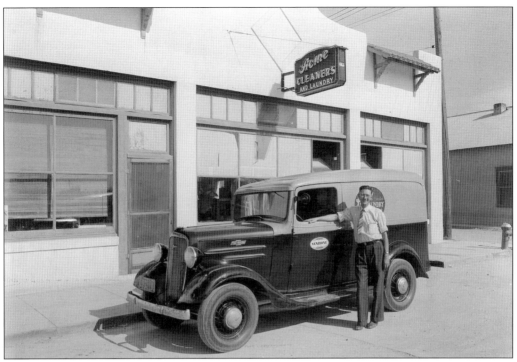

Ernest L. Ritchie, manager of Acme Laundry and Cleaners at 500 North Main, proudly poses with his delivery truck on September 26, 1940. (Courtesy of NMSULASP.)

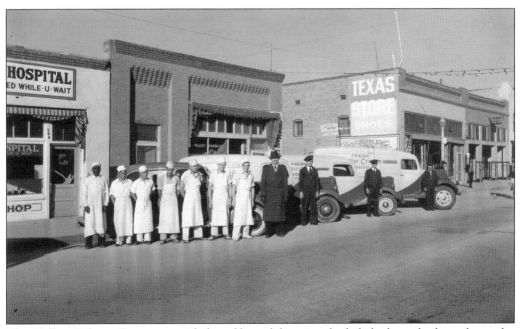

The Valley Baking Company prided itself on delivering fresh baked goods throughout the Las Cruces area. Snappily painted delivery vans with uniformed drivers suggest how much the company cared about its image. Would we witness such foppishness in modern times? (Courtesy of NMSULASP.)

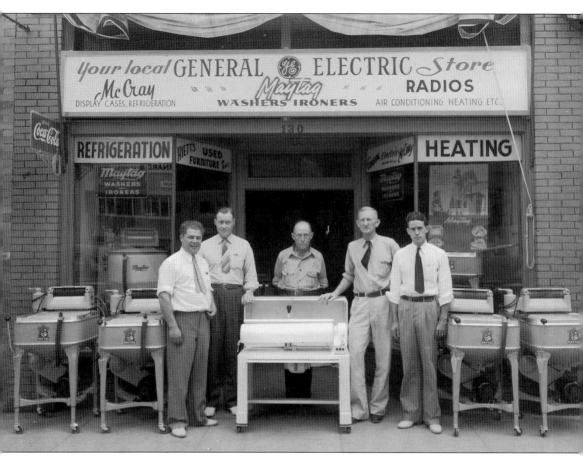

Hiett's Appliances offered name-brand appliances. This quintet appears to be ready to serve the public with the latest in heating and cooling equipment, radios, washers, and ironers in 1959. The washers shown probably rolled up to the sink and were attached to the sink faucet. The "mangle" ironer in the center was perfect for ironing sheets and other large, flat pieces. (Courtesy of NMSULASP.)

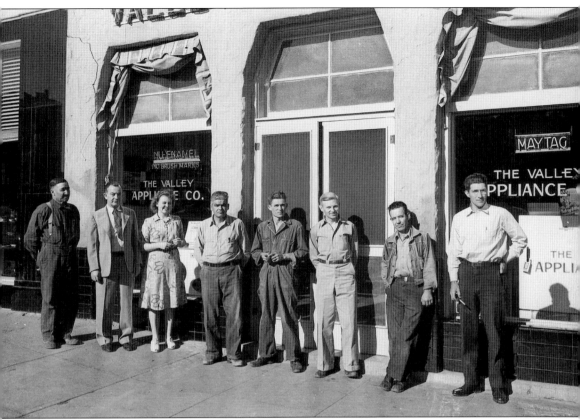

The Valley Appliance Company also featured quality Maytag appliances. One might wonder if the company had already established a reputation for low maintenance products. The Valley Appliance Company competed with Hiett's Appliance since both sold Maytag products. (Courtesy of NMSULASP.)

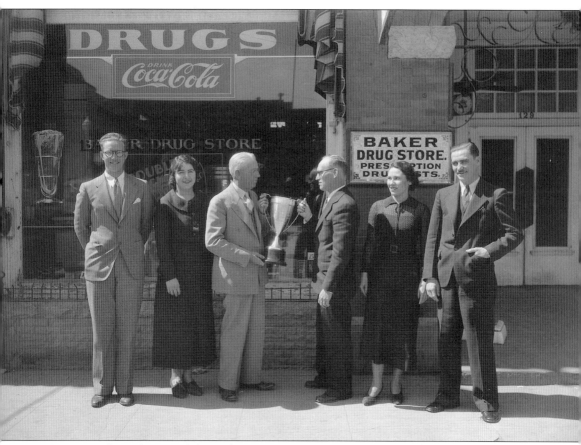

Owners and employees of the Baker Drug Store proudly receive an award in front of their establishment, which prominently featured Coca-Cola products for their soda fountain. (Courtesy of NMSULASP.)

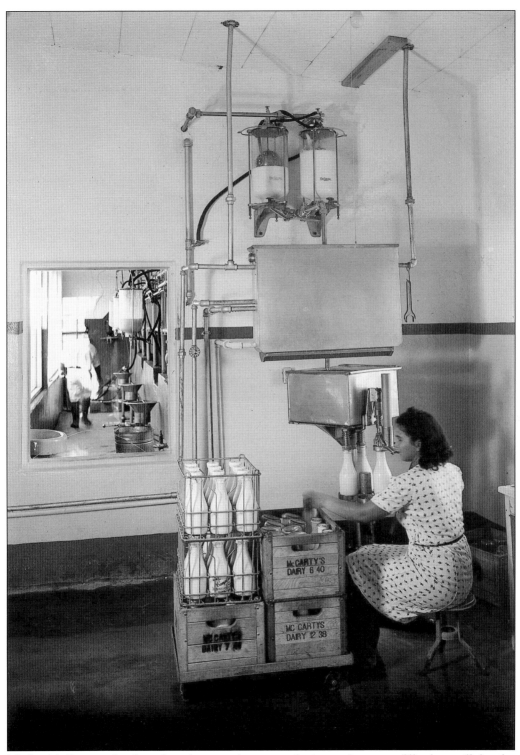
McCarty's Dairy utilized modern dairy production techniques. A woman fills glass milk bottles to be delivered door to door by the friendly milkman. (Courtesy of NMSULASP.)

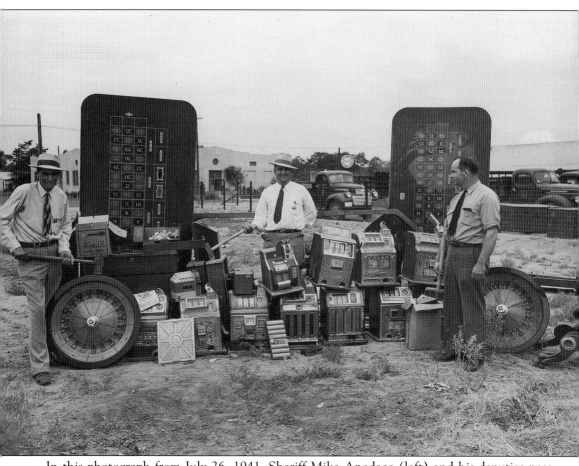

In this photograph from July 26, 1941, Sheriff Mike Apodaca (left) and his deputies pose with $3,000 worth of confiscated slot machines, dice tables, roulette wheels, chips, dice, and other gambling accessories seized by the Doña Ana County sheriff's department. The sheriffs raided the Castle and Tropics nightspots in Las Cruces as well as clubs near the New Mexico-Texas border. (Courtesy of NMSULASP.)

Commemorating the introduction of natural gas to Las Cruces on July 15, 1936, Mayor George W. Frenger was quoted in the newspaper, saying, "our little community now offers everything in the shape of conveniences that any metropolis has." He also asked all residents to "encourage people to establish their homes here, in 'The Friendly City'." (Courtesy of NMSULASP.)

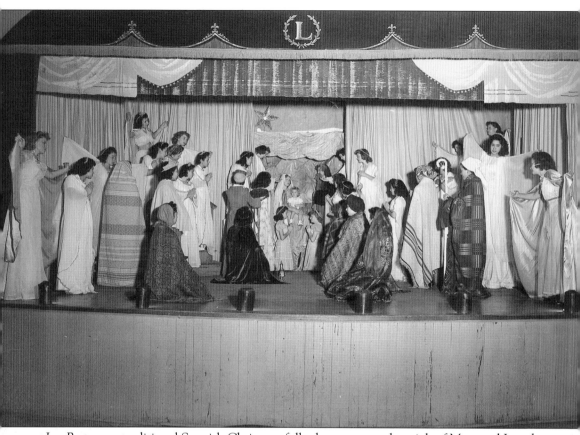

Los Pastores, a traditional Spanish Christmas folk play, reenacts the trials of Mary and Joseph as they searched for shelter in Bethleham. This *Los Pastores* was presented by students at Loretto Academy on December 24, 1942. (Courtesy of NMSULASP.)

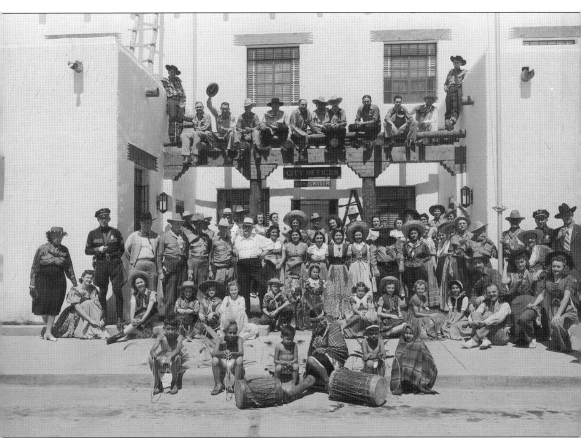

A group of enthusiastic Las Crucens pose in front of the county courthouse for a fiesta celebration in a photograph that illustrates the wide variety of cultures and heritage in Las Cruces's history. In July 1941, this crowd enthusiastically celebrated the Fiesta de la Frontera in commemoration of the 400th anniversary of Coronado's exploration of New Mexico. (Courtesy of NMSULASP.)

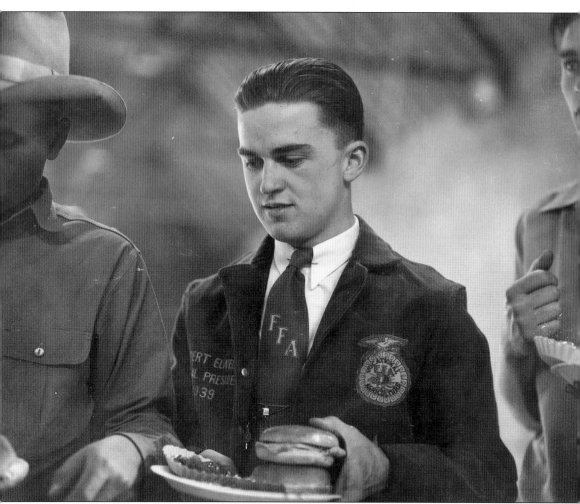

Members of the Future Farmers of America prepare to eat their burgers at an FFA convention on April 12, 1939 in Las Cruces. When the FFA was founded in 1928, there were only 33 student members. In 2003, it celebrated its 75th anniversary with over 457,000 members nationwide. (Courtesy of NMSULASP.)

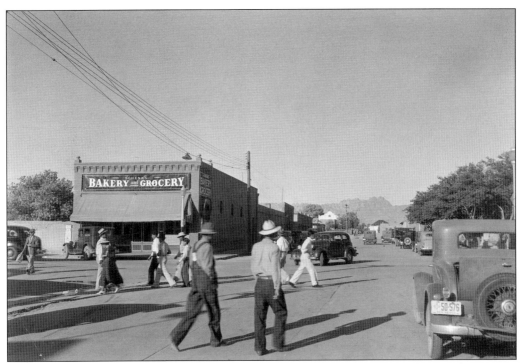

Las Crucens dodging cars look east down Las Cruces Avenue toward the familiar Organ Mountains as they cross Main Street. Schenk's Bakery and Grocery on the left had been selling confections since the 1890s. (Courtesy of NMSULASP.)

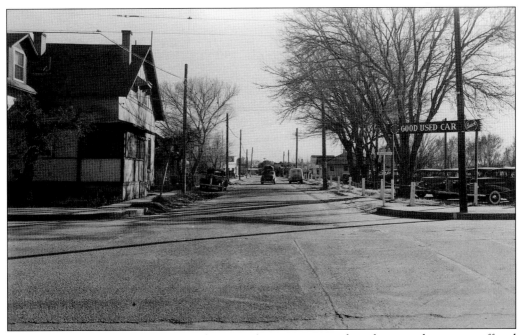

With World War II halting the production of new cars, a used car lot near downtown offered previously owned vehicles for those people carless in Las Cruces. (Courtesy of NMSULASP.)

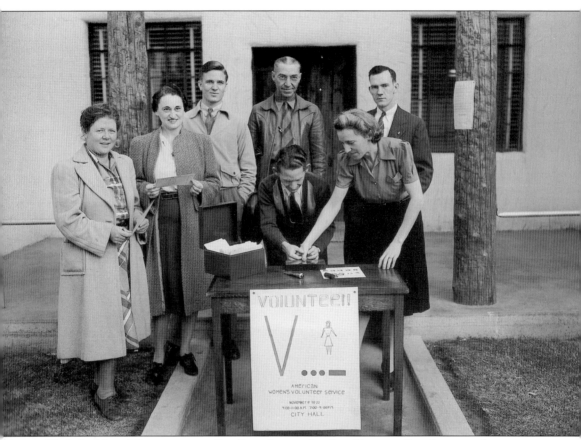

With the United States not yet officially in the war, but Lend Lease well underway and preparations being made on the home front for the coming war, Mrs. Feather of the American Women's Volunteer Service is fingerprinted on November 19, 1941. (Courtesy of NMSULASP.)

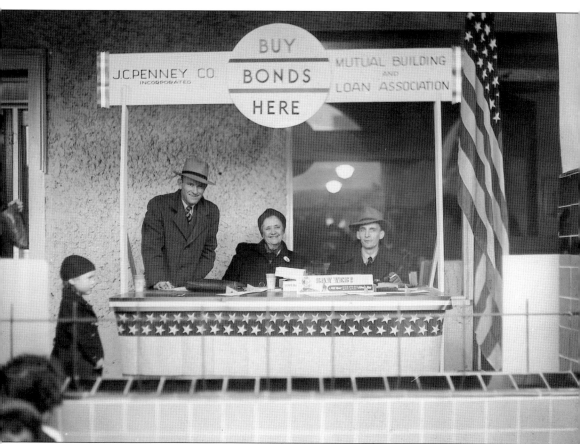
In order to support the war effort, Las Crucens bought war bonds at their local J.C. Penney's store on Main Street in this photograph from January 8, 1943. (Courtesy of NMSULASP.)

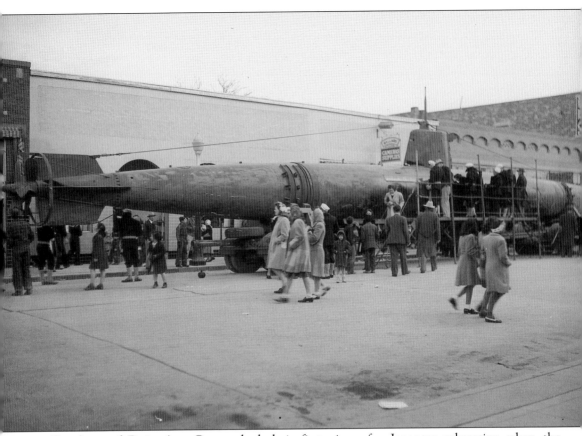

Residents of Doña Ana County had their first view of a Japanese submarine when the U.S. Treasury brought the two-man suicide torpedo boat to Las Cruces on January 8, 1943 as part of its national war bond sales drive. The submarine was captured during the Japanese attack on Pearl Harbor, Hawaii on December 7, 1941. Navy trainees attending the mechanics' school at New Mexico A&M College (now NMSU) escorted the tractor-trailer carrying the 81-foot, 20-ton submarine into downtown Las Cruces. Five thousand Las Crucens, including school children, helped raise $100,800. Those who bought a war savings stamp or bond were able to look inside the submarine where two "Japanese" sailor figures were dressed in proper uniforms at their battle stations, ready to launch two torpedoes. At the completion of its month-long tour, the submarine had raised $4 million worth of war bonds. (Courtesy of NMSULASP.)

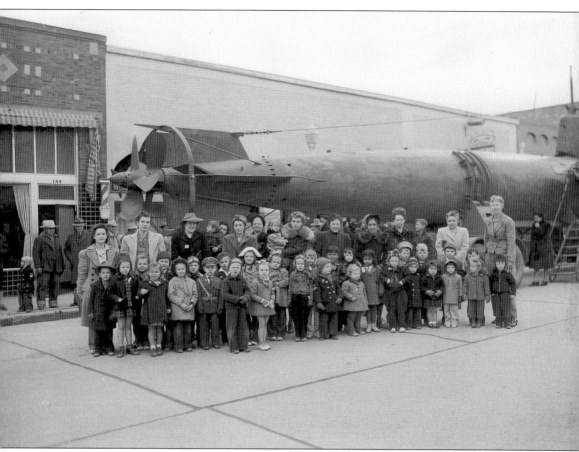

Excited children from Mrs. Heath's kindergarten class pose in front of the captured Japanese submarine in front of the Service Men's Center, at 115 South Main Street. (Courtesy of NMSULASP.)

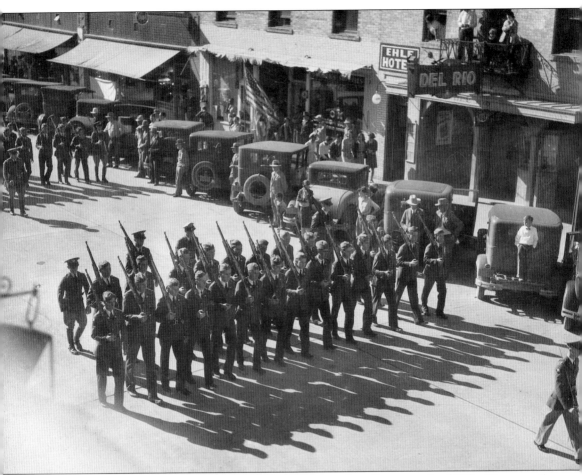

The New Mexico State University ROTC marches in Las Cruces in the 1930s. The swastikas on their shoulder patches were adopted from local Native American cultures, but were dropped from their insignias during World War II. (Courtesy of NMSULASP.)

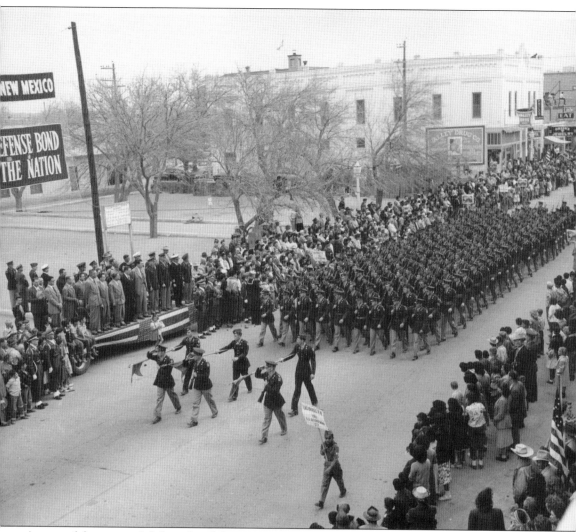

As part of the national defense bond drive, a military parade passes in front of the plaza in front of St. Genevieve's Church on Main Street on January 8, 1943. (Courtesy of NMSULASP.)

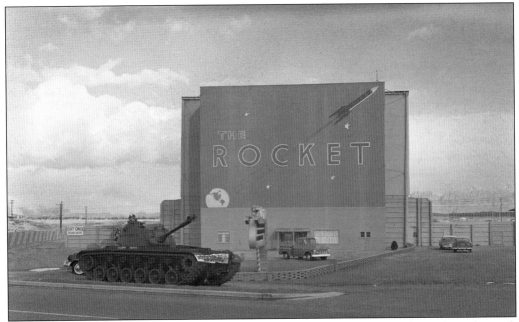
The Rocket Drive-in Theatre was located on North Main Street during the 1950s. The tank parked in front of the drive-in was used for promotional reasons. (Courtesy of NMSULASP.)

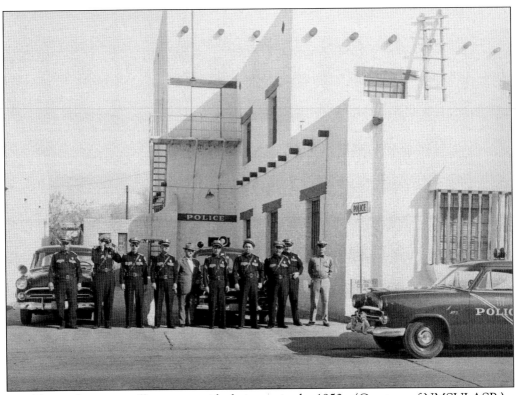
Local law enforcement officers pose with their cars in the 1950s. (Courtesy of NMSULASP.)

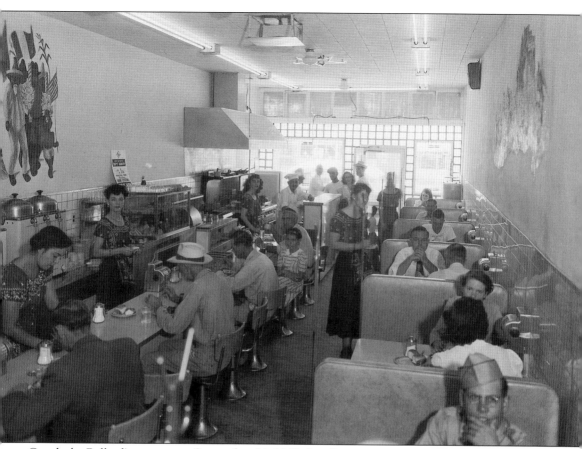

Caught by Ballard's camera on September 14, 1949, Las Crucens enjoy conversation and a meal while sitting at the busy Boston Café counter in downtown Las Cruces during the booming postwar years. (Courtesy of NMSULASP.)

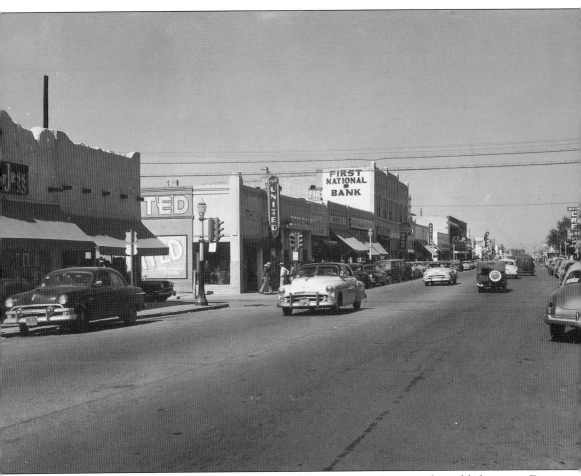

Main Street during the 1950s was active with a mixture of cars and establishments. First National Bank had been a mainstay since the 1910s. Looking north, notice the sign for a liquor store on the right. In the next photo, that same sign hangs off of the Hotel Herndon. (Courtesy of NMSULASP.)

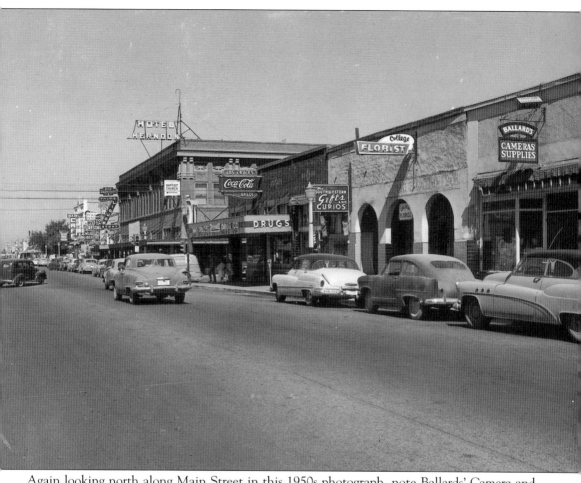

Again looking north along Main Street in this 1950s photograph, note Ballards' Camera and Supply Store, a company that documented Las Cruces life through his camera lens. The majority of the photographs in this book come from Ballards' collection of photographs at NMSU's Rio Grande Historical Collection. (Courtesy of NMSULASP.)

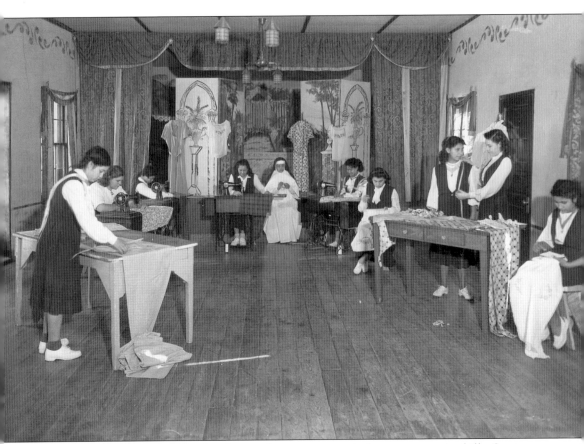

The Sisters of the Good Shepherd trained young women in home economic skills. Sewing was certainly one of those skills and several of the girls used electric sewing machines while others perfected their hand-sewing technique. (Courtesy of NMSULASP.)

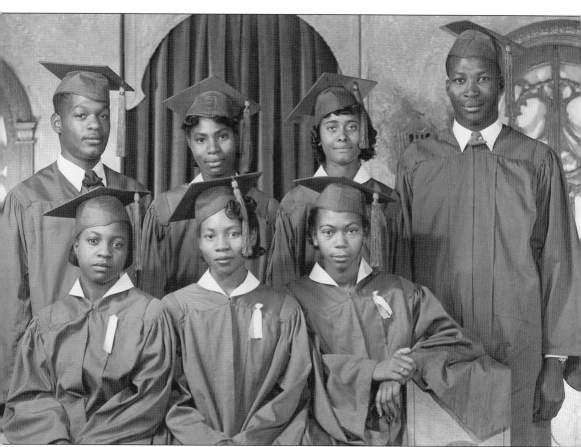

This undated photograph shows a graduating high school class from the segregated Booker T. Washington School. School segregation of African Americans came to Las Cruces in the 1910s after cotton farmers moved in to take advantage of the new Elephant Butte irrigation waters. The Booker T. Washington School at 755 East Chestnut covered all grades. (Courtesy of NMSULASP.)

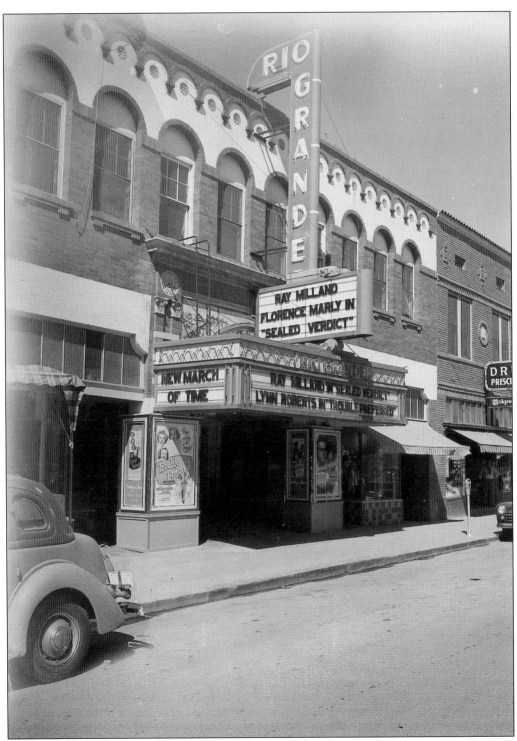

The Rio Grande Theater, located on Main Street, is a unique two-story adobe structure designed by architect Otto H. Thorman. First opened on July 29, 1926, pictured here the theater is showing "Sealed Verdict," which was released in 1948. (Courtesy of NMSULASP.)

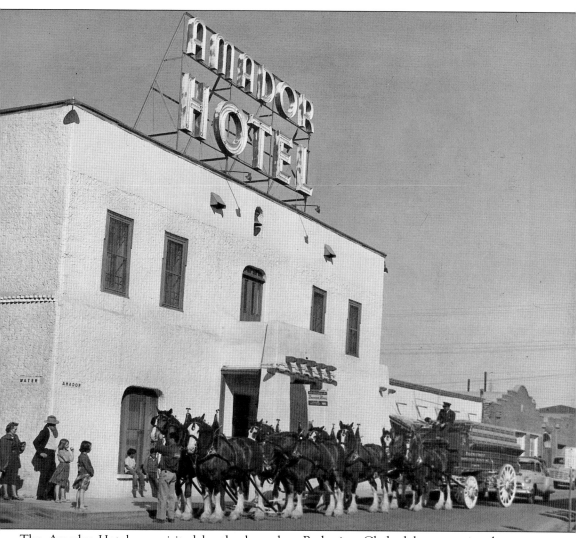

The Amador Hotel was visited by the legendary Budweiser Clydesdale promotional team in the 1950s. The hotel is now the location of the Doña Ana County Manager's Complex. (Courtesy of NMSULASP.)

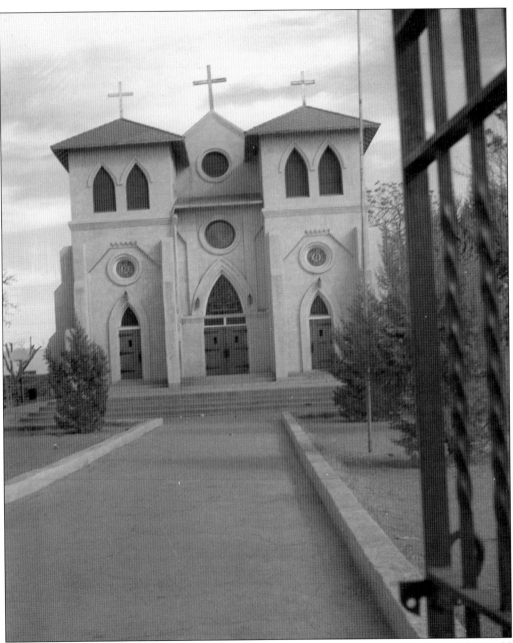

St. Genevieve's Church went through several structural changes over its lifetime. This 1955 photo shows how it looked before it was demolished in 1967. Sold by the Catholic diocese, the destruction of this vital part of downtown continues to be lamented. The steeples of St. Genevieve's were shortened during the 1930s due to structural problems. See pages 76 and 77 to see the steeples being reduced in the center left of the aerial view. (Courtesy of NMSULASP.)

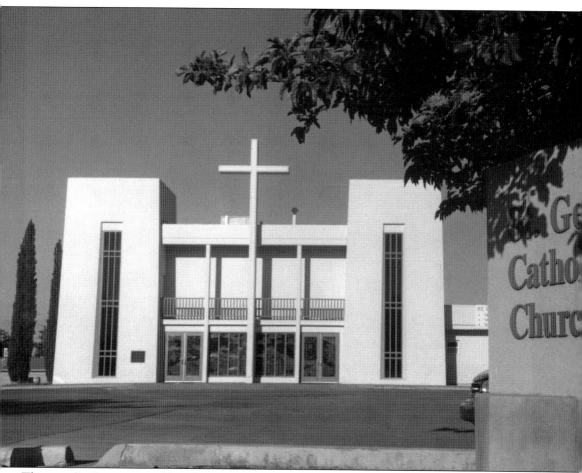

The new St. Genevieve's Church at 1025 East Las Cruces Avenue, ten blocks east of the site of the original church site, is now on the eastern edge of the Mesquite Original Townsite Historic District. The new St. Genevieve's Catholic Church continues to serve the faithful of the downtown and Mesquite areas. (Photo by J. Hunner.)

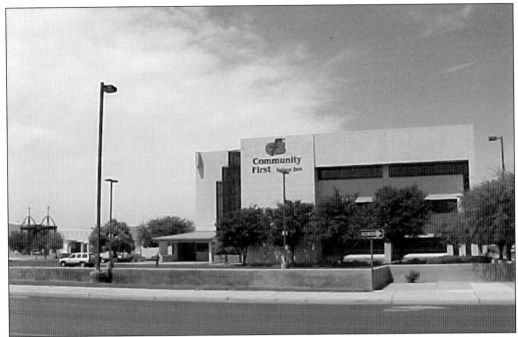
Looking west from Church Street, this view shows the Community First National Bank at 201 North Church Street, which sits where the old St. Genevieve's plaza was located. The church building itself would have been in the parking lot on this side of the bank building. The Rio Grande Theater is on the other side of First Community. Note the monument to St. Genevieve's on the far left. (Photo by J. Hunner.)

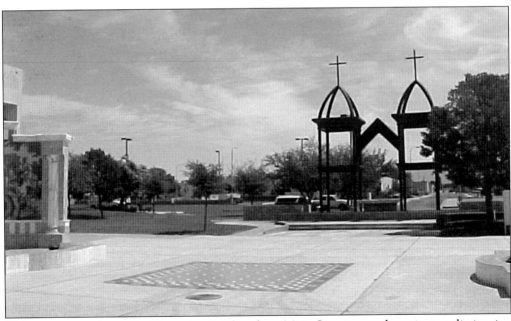
A monument to the old St. Genevieve's Church on Main Street reproduces its two distinctive steeples. The old church was behind these monuments and in front of City Hall (seen in background on the left with the arched doors). (Photo by J. Hunner.)

Four

URBAN RENEWAL CHANGES THE HEART OF LAS CRUCES

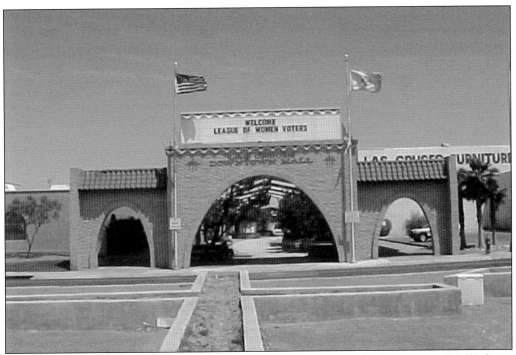

Looking north to where Main Street used to run, this entrance to the "Downtown Mall" shows the radical change that occurred when urban renewal transformed the downtown area in the 1970s. Many of the current photos in this chapter can best be appreciated by going back to the historic photos referenced in the captions. (Photo by J. Hunner.)

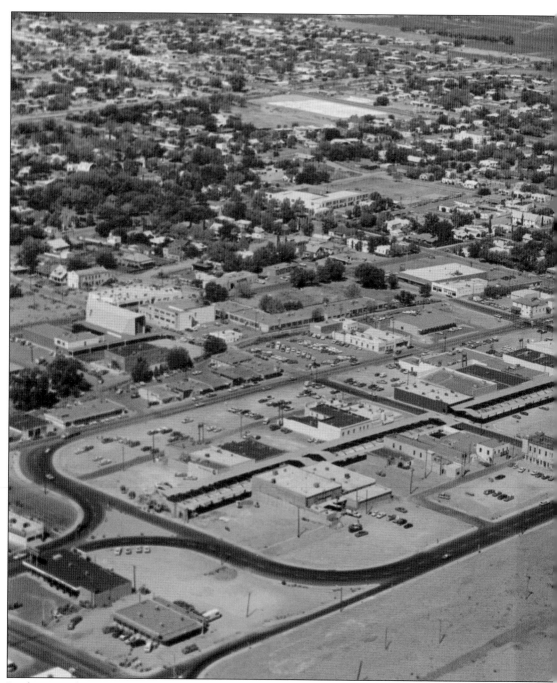

Looking northwest over the downtown district, this aerial view from the early 1970s shows the changes to Main Street and the Mesquite District east of downtown. The vacant dirt lots that run diagonally from the bottom center to the upper right used to contain hundreds of adobe buildings. The only structure in that wide swath of destruction shown here was the newly built City Hall. The vacant lot to the south with the parked cars is where the new federal courthouse will be built in the near future. The old post office (see page 51, bottom) is the dark-roofed building to the left of parking lot. Main Street runs diagonally one block to the left of the old

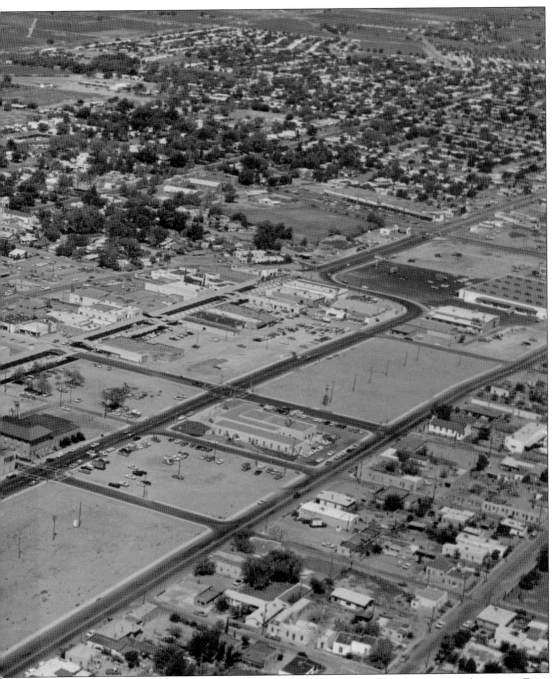

post office. Beginning in the mid 1960s, urban renewal accomplished two main objectives. First, it blocked off Main Street to make it a walking street, called the "Downtown Mall." Second, the block-wide swath of vacant lots between Church Street and San Pedro Street became the sites for other municipal and federal buildings, including a federal courthouse, the city's central post office, and to the north, the Branigan Public Library. The cost of urban renewal totaled almost $13 million. (Courtesy of NMSULASP.)

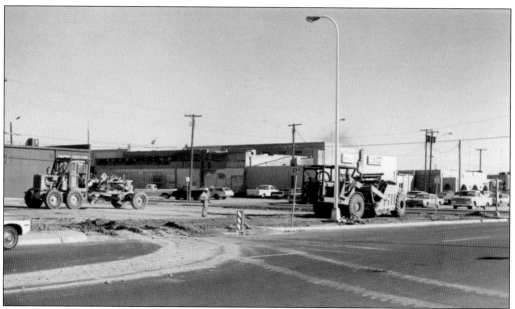

In the fall of 1973, earth-moving machines level the land where historic adobes used to reside. Some of these lots are still used as parking lots. (Courtesy of NMSULASP.)

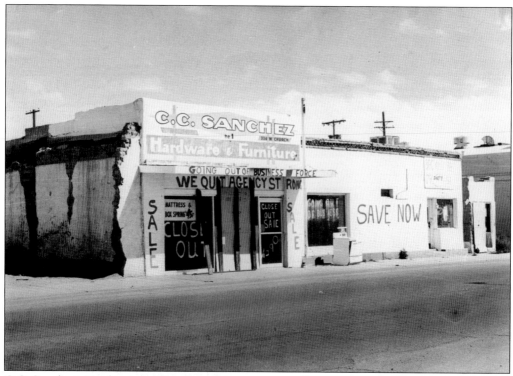

C.C. Sanchez's Hardware and Furniture Store went out of business as its building was condemned by urban renewal. Like 198 other businesses and private residences in the downtown area, Sanchez had to leave his location. All of the families and some businesses relocated. Others like Sanchez called it quits. (Courtesy of NMSULASP.)

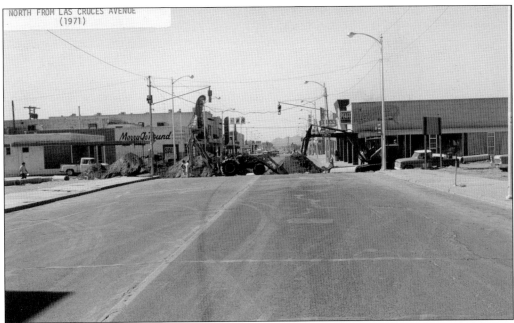

Looking north along Main Street from Las Cruces Avenue in 1971, heavy equipment begins the work in transforming Main Street into the "Downtown Mall." Urban renewal of downtown was thought to be the cure for the loss of businesses to retail malls in other parts of Las Cruces. (Courtesy of NMSULASP.)

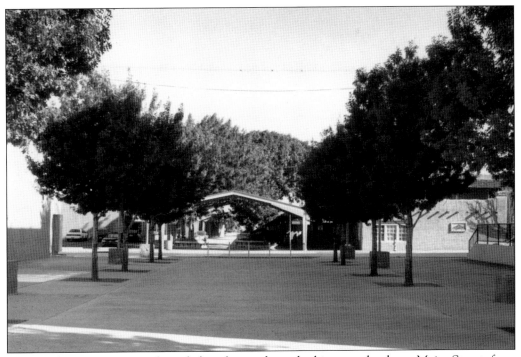

This is the same view today of the above photo looking north along Main Street from Las Cruces Avenue. (Photo by J. Hunner.)

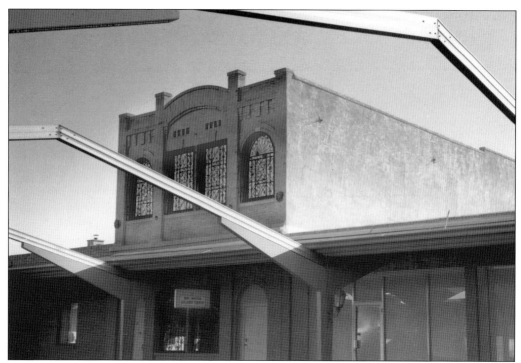

Added to the blocked-off Main Street for shade, these covered awnings sometimes hide the historic buildings that still exist in the downtown area. This block was where Ballard had his photography studio (see page 105). (Photo by J. Hunner.)

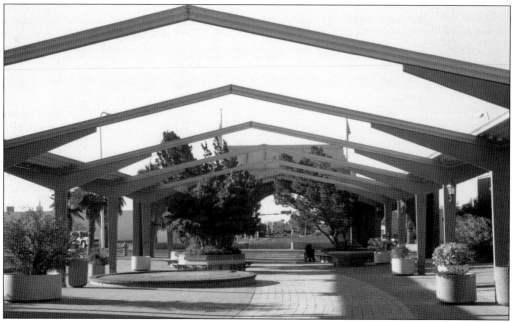

Looking south towards where the Loretto Academy used to be (see page 11, top), this shows the awnings, trees, benches, and planters placed there to make the "Downtown Mall" friendlier for pedestrians. (Photo by J. Hunner.)

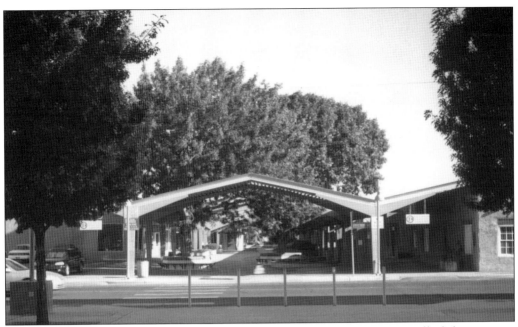

Many businesses still call the downtown area home, but the "Downtown Mall" fails to attract many pedestrians except during the Whole Enchilada Fiesta in October and the weekly Farmers' Market. (Photo by J. Hunner.)

A revitalization movement to bring life back to Downtown Main Street is working to rehabilitate the Rio Grande Theater, possibly return two-way traffic to Main Street, and assist the businesses in the area with economic development. (Photo by J. Hunner.)

Modern buildings and metal awnings mark the intersection of Griggs and Main Streets seen on page 54. (Photo by J. Hunner.)

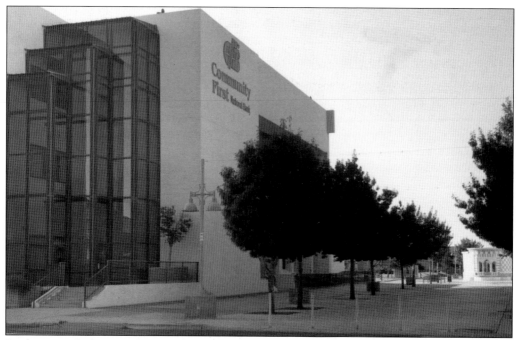

Looking south down Main Street past the First Community Bank on the left, this section of downtown was the nucleus of social and religious activity until the 1960s. This block in front of St Genevieve's Church was the location where the soldiers marched past on page 101. (Photo by J. Hunner.)

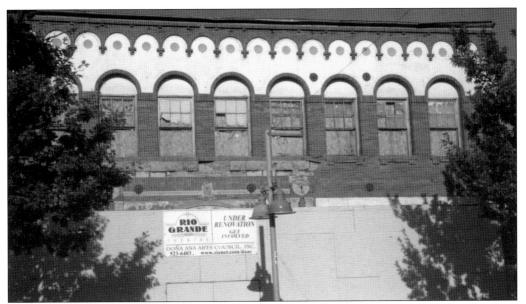

The Rio Grande Theater awaits rehabilitation. In 1998, Jan and Mickey Clute and Caroline and Bruce Muggenburg donated their half interest in the theater to the Doña Ana Arts Council, which successfully raised the rest of the purchase price. When renovated, the Rio Grande Theater will serve as a venue for live performances, movies, traveling shows, and a place that school groups and community organizations can use for educational purposes. (Photo by J. Hunner.)

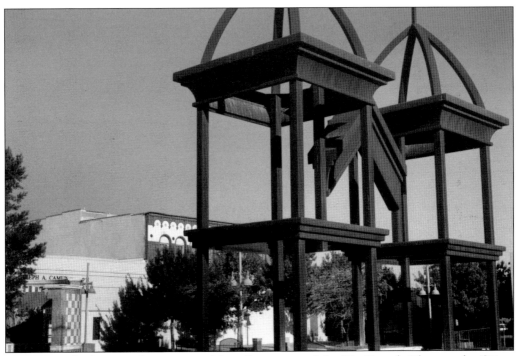

In this view looking northwest across Main Street toward the Rio Grande Theater, the Oñate Monument on the left and the St. Genevieve's Monument on the right mark the center of downtown. (Photo by J. Hunner.)

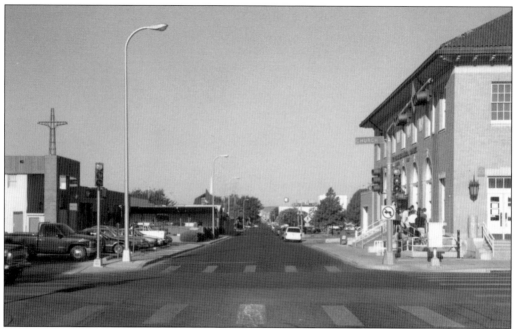

With the old post office (now the municipal courthouse) on the right at the intersection of Church Street and Griggs Avenue, the cityscape of Las Cruces shows the effects of urban renewal (see page 51, bottom for an earlier view). (Photo by J. Hunner.)

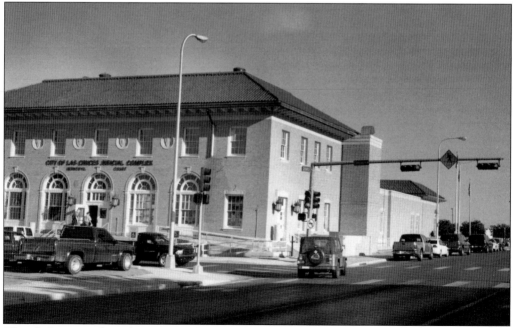

Church Street on the right runs past the Municipal Courthouse. To make Main Street a pedestrian mall, traffic had to be rerouted to streets east and west of downtown. Now called "The Racetrack," the oval around Main Street which includes Church Street allows cars to zoom around the downtown as they rush elsewhere (see page 20, top, for an earlier view). (Photo by J. Hunner.)

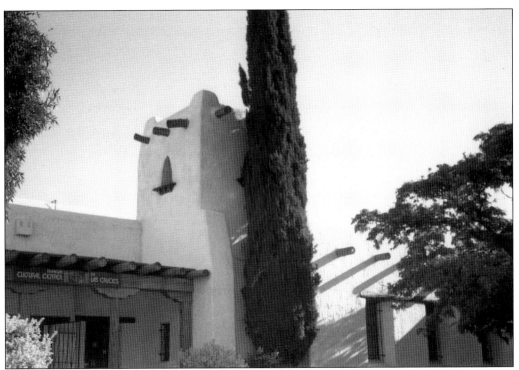

The old Branigan Library became the Branigan Cultural Center when the new city library was built in 1979. As a Depression-era building, the Branigan Cultural Center retains much of its integrity as it continues to showcase the history and heritage of the Mesilla Valley. (Photo by J. Hunner.)

Another well-preserved building from Las Cruces's past, the W.I.A. Club at Pioneer Park held the first public library in Las Cruces (see page 72). (Photo by J. Hunner.)

The Court Junior High School, built by the Works Progress Administration in 1940, turned into the Court Youth Center in 1995 (see page 73, bottom). A place for after-school activities and community events, the Court Youth Center was saved from demolition and has undergone extensive renovations as a good example of how old buildings can be adapted for contemporary use. (Photo by J. Hunner.)

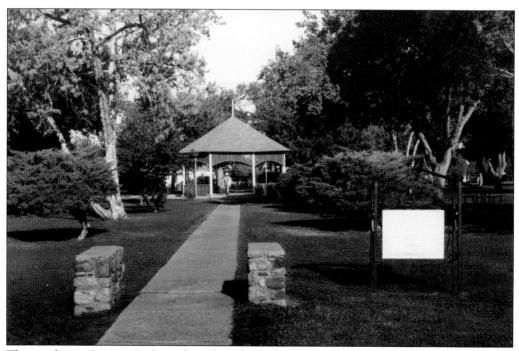

The gazebo at Pioneer Park in the Alameda Depot Historic District continues to serve the neighborhood as it did in the past (see page 70). (Photo by J. Hunner.)

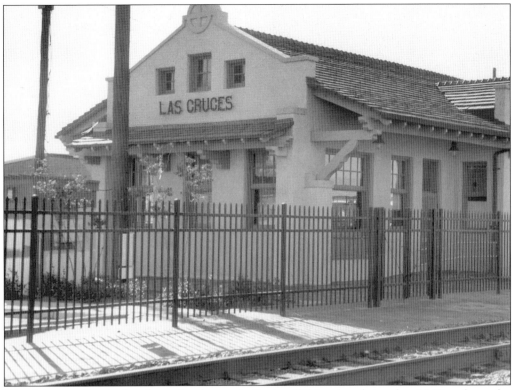

The Mission Revival-style train depot, built in 1910, closed in the 1960s when the Atchinson, Topeka and Santa Fe Railroad ended passenger service on this route (see page 37). (Photo by J. Hunner.)

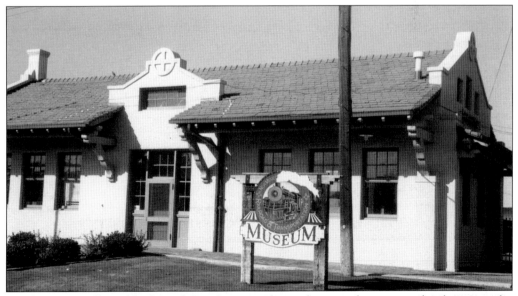

Freight trains still rumble through Las Cruces and past the train depot every day; however, the glory days of passenger trains where presidential campaigns made whistle stops at Las Cruces are long gone (see page 43). (Photo by J. Hunner.)

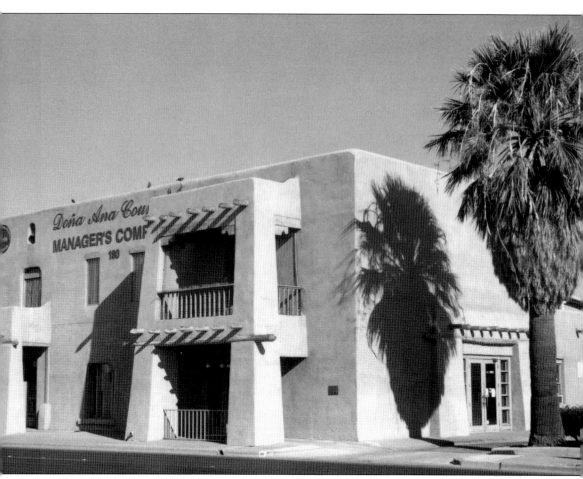

The Doña Ana County Manager's Complex at 180 West Amador Avenue used to be the Amador Hotel (see page 39, bottom). Having undergone extensive changes, it is no longer recognizable as the remains of the oldest hotel in Las Cruces. (Photo by J. Hunner.)

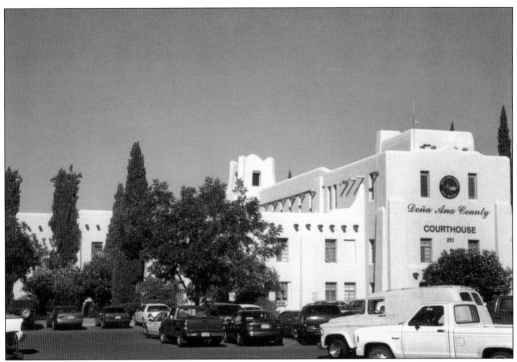

The Doña Ana County Courthouse, built in 1937 by the Public Works Administration, continues to hold the county's administrative offices and jail facility. (Photo by J. Hunner.)

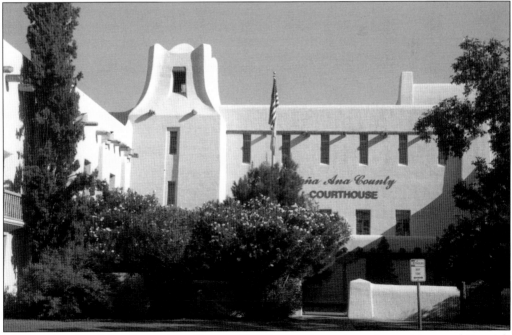

The south side of the Doña Ana County Courthouse shows how the architectural Spanish Pueblo Revival style that originated in Santa Fe in the 1910s spread throughout the region. (Photo by J. Hunner.)

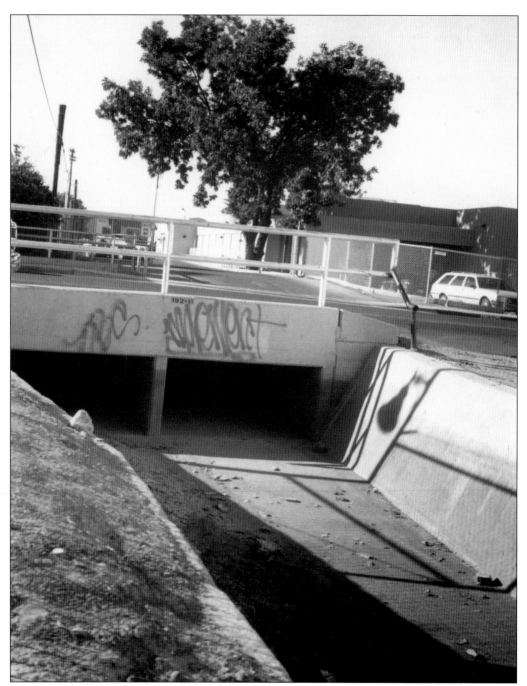

Looking south along the dry Acequia Madre (the irrigation ditch that dates back to the founding of Las Cruces in 1849), the once vital source of water for downtown Las Cruces is now controlled by the Elephant Butte Irrigation District (EBID). Now called the Las Cruces Lateral, the concrete-lined ditch which runs just west of Water Street still carries water to residences and farmers in the valley. However, as a result of the drought, water released by the EBID does not fill the ditch as often. This photo was taken from almost the same view as that shown on the bottom of page 42. (Photo by J. Hunner.)